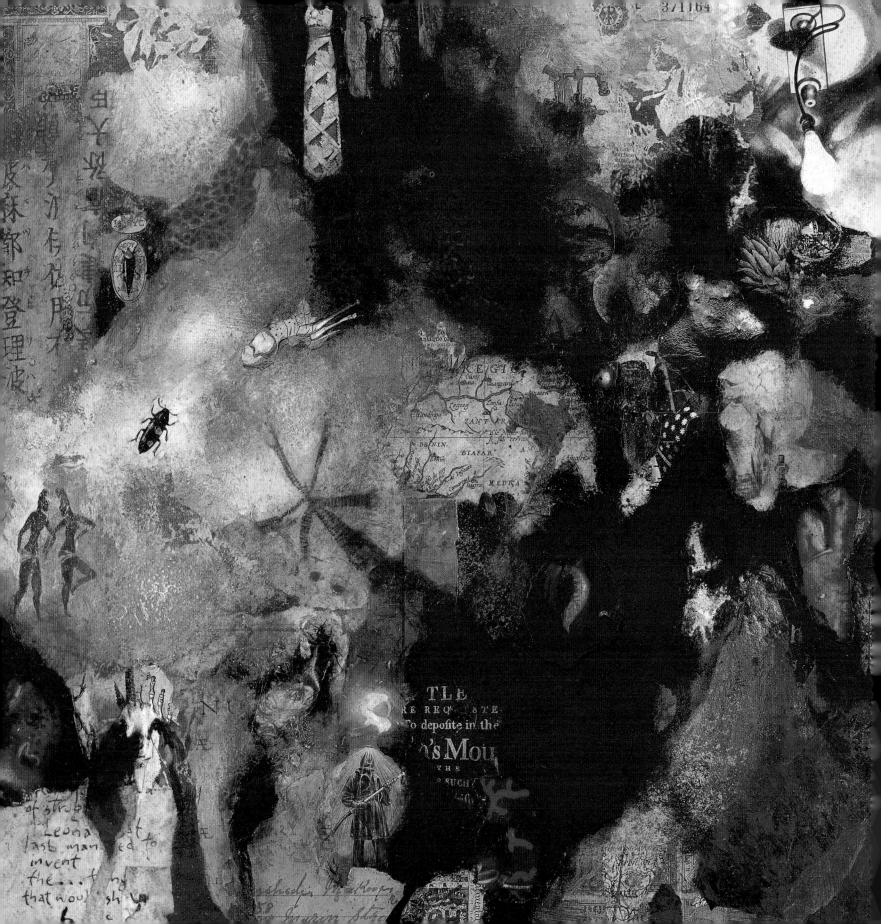

the ARTFUL DODGER

the ARTFUL DODGER
Images & Reflections

NICK BANTOCK

CHRONICLE BOOKS
SAN FRANCISCO

Printed in Hong Kong.

Library of Congress Cataloging-in-Publication Data available.

ISBN 0-8118-2752-6

Art direction by Byzantium Books
Cover and text design by Jacqueline Verkley
Cover photograph by Robert Keziere

10 9 8 7 6 5 4 3 2 1

Chronicle Books
85 Second Street
San Francisco, CA 94105

www.chroniclebooks.com
www.griffinandsabine.com
www.fan-dango.com

DEDICATION
To my four children, Paul, Kate, Ruth, and Holly,
whom I love from the bottom of my heart.

ACKNOWLEDGMENTS
Lucky man. Over the years many, many people have helped me with both my art and
my books; a list of acknowledgments would probably take reams, and I'd hate to accidentally
miss someone. So, to everyone who's assisted, supported, and encouraged me . . . Thank you.
I hope you see yourself between the lines and smiling out of the shadows of
The Artful Dodger.

NB

Fiction

Griffin & Sabine (Chronicle, 1991)

Sabine's Notebook (Chronicle, 1992)

The Golden Mean (Chronicle, 1993)

The Egyptian Jukebox (Viking, 1993)

Averse to Beasts (Chronicle, 1994)

The Venetian's Wife (Chronicle, 1996)

Paris Out of Hand (collaboration) (Chronicle, 1996)

The Forgetting Room (HarperCollins, 1997)

The Museum at Purgatory (HarperCollins, 1999)

Pop-up Books

There Was an Old Lady (Viking, 1990)

Jabberwocky (Viking, 1991)

Wings (Random House, 1991)

Solomon Grundy (Viking, 1992)

The Walrus and the Carpenter (Viking, 1992)

Runners, Sliders, Bouncers, Climbers (Hyperion, 1992)

Robin Hood (Viking, 1993)

Kubla Khan (Viking, 1994)

Other

The Missing Nose Flute (postcard book) (Chronicle, 1991)

Griffin & Sabine Address Book (Chronicle, 1994)

Griffin & Sabine Notecards (Chronicle, 1994)

Griffin & Sabine Writing Box (Chronicle, 1994)

Griffin & Sabine Postcard Box (Chronicle, 1996)

Ceremony of Innocence (CD-ROM) (Real World, 1997)

Capolan Artbox (box with notecards & book) (Chronicle, 1997)

Capolan Journal (Chronicle, 1997)

Contents

My work is a rag-bag,

a dice box,

a wheel of fortune,

and I am a mongrel

with a passion

for parallax views.

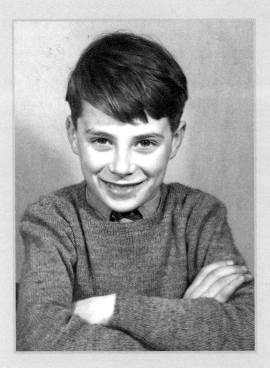

D'arts

SEIZE THE DAY

During my last year at art college, having nothing better to do one dull Friday afternoon, I ambled down to the local pub. Surprisingly, there was only one other student in the public bar, a stringy-haired Welsh lad practicing his darts. 'The Celt' was generally accepted as the best darts player in the school; thus he was obliged to put in many hours to keep up his reputation. I wasn't in his league, but I had aspirations. So I bought myself a pint of bitter (the dreaded Watneys Red Barrel of *Monty Python* fame) and challenged him. We agreed on a game of 101 just to warm up, then we threw for the middle and as my dart landed closest, I got first chuck. The ideal 101, though rarely achieved, requires a player to throw double seventeen, followed by a single seventeen and then a bull's-eye. Feeling in a confident mood, I went for the coup de grâce. My first two darts homed in like pigeons, leaving me the bull still to hit. I took aim, fired . . . and stagger me if I didn't get it! Only trouble was, the dart clipped the wire, found little purchase, and started to droop backwards. The rule states that if you retrieve your dart before it actually falls out, then the score counts. I dived full-length at the board and grabbed it just as it was wilting away.

The king was dead! It was a crowning moment—the highlight of my college career—and I certainly wasn't going to hang around and play another game. So I downed my beer in a gulp and marched out of the pub.

Once I was in the fresh air, I realized there was no point staying in town, because I'd nothing else to do. So I hopped on a passing bus, just caught the train into London, made the tube by a gnat's whisker, and so found myself on my local station platform. It was there that I occasioned upon an ex-school friend, who invited me to a party later that evening on the other side of London. I went home, changed, and headed for the bright lights. At the party I met a young woman called Bean (no relation to the notorious Mr.) and we subsequently began dating. We went out for a month, then drifted apart.

Two years later I was working in a betting shop in the East End of London, when on a lunch

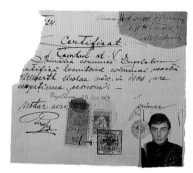

TOP: Fictitious Capolan exit visa for the sixteen-year-old Nick Bantock. The photo came from my first passport. FACING PAGE: Eight-year-old Nicholas wearing his best school sweater and his best school smile.

break I bumped into Bean again. She was with Nic, her current boyfriend, who worked for a big advertising agency. We got to talking, and he told me that they were involved in a campaign for the Save the Children's Fund, but the photos that had been taken by Lord Snowden weren't quite what they were looking for. They were thinking of switching to graphite drawings. Bean piped up that I used to be a wiz with a pencil and, in the casual tone of the period (1971 was very laid-back), Nic invited me over to his office the following day to show him my portfolio. I didn't have a portfolio, so I shoved some of my old drawings into a case and trundled round to the plush offices of KMP. I was, in all honesty, completely naive, and oblivious, to the lucky break that had come my way. To cut a long story short, I was offered a trial commission, and two days later, when I presented my Starving Infant drawing, I was asked to do a further four pictures, each paying 1000% more than I earned per week at the betting shop. Hence, not being completely foolish, I decided to became an illustrator, which in turn drew me on to doing book covers, which eventually took me to making my own books and everything else that's sprung from them.

What, you may ask, has any of this to do with darts? The answer is simple. If I hadn't snagged the dart before it could fall from the bulls-eye, I'd have stayed in the pub, played another game, missed Bean, and failed to instigate the chain reaction that led to the events I've just described.

Okay, of course you could look back and see hundreds, maybe thousands of those kinds of fulcrums in any given day, but that's the point: The threads of circumstance that lead to tomorrow are so tenuous that all the fussing and worrying about decisions is futile compared to the pure randomness of existence. And I must admit I like that. I like it that my career has all the predictability and continuity of a children's nonsense rhyme.

TOP: Mephistophelian posing for *Averse to Beasts*.

FACING PAGE: In 1967 I visited San Francisco for the first time and, not wishing to stand out, I dressed accordingly. Photograph by Pat Woodward.

Art College

INEPTITUDE

I left school at the age of fifteen, without purpose or direction. Nowadays it seems ludicrously young, but it wasn't so unusual back then, particularly if you weren't destined for scholastic greatness. However, I had no desire to go to work, nor did I want to embark on anything remotely requiring further academic study. Applying Sherlock Holmesian logic and discarding that which I deemed unacceptable, I was faced with only one alternative: I applied to the local art college to become an artist. This tawdry backdoor decision should, by rights, have led me absolutely nowhere. Instead, it set me off on a path that would ultimately be remarkably gratifying.

Somewhat to my surprise, I was accepted into the art department of Loughton College of Further Education (an inelegant concrete and glass erection residing in the depths of the London suburbs). Into that establishment I took with me all the maturity and artistic skills of a newborn newt. Some months later, when I'd veered into competence, the head of the department casually informed me that he was quite surprised at how I'd turned out, because he'd only taken me on to make up the numbers. His brutal truth made me flinch, but it was valid, because during that first term I'd resolutely proven that I couldn't draw in proportion, couldn't make three marks without erasing two, and had virtually no color sense.

Then came the miracle. The moment I picked up a pencil on my return from the Christmas break, I immediately noticed a change. It no longer felt awkward in my hand. It nestled there quite contentedly, and when I began drawing my fingers seemed to know exactly where to take it. A magic wand had been waved somewhere, gears had moved, cogs had clicked, and instead of producing tentative ineffectuality, I found myself creating with assurance and, for that matter, even a degree of vitality. Proportion wasn't a problem, and I barely used my eraser (in England they're called rubbers, which made for some curious conversations the first time I visited the States). I had gone, seemingly without effort, from being a nonstarter to showing distinct signs of capable draftsmanship. But my color sense wasn't going to improve for ten

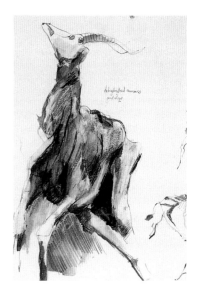

FACING PAGE & ABOVE: Two colored drawings from my first art college sketch book. Cheap powdered paint and black pencil. (1965)

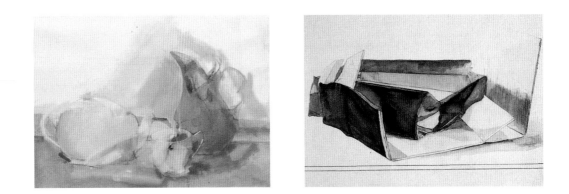

TOP LEFT: By the age of seventeen I was learning to let the oil paint drip across the canvas in a "painterly" manner. (1967)
TOP RIGHT: Gouache painting of a crushed matchbox. Sometimes I was a little lost for subject matter. (1968)

years. And it would take me a further fifteen to learn to direct my technical facility. Yet even if I'd known that, I wouldn't have protested, because at last I felt like I had finally stumbled onto home territory.

LIFE CLASS

The really big event in my early days at art college was our first life-drawing class. I was barely sixteen and I'd never seen a naked woman before. I was both excited at the prospect and scared stiff that I'd find some way of embarrassing myself. I'd discussed the matter with my friend Steve, who was also suffering from heavy attacks of conflicting expectation. He and I used to travel on the train together, and on the morning of the great event, we noticed a beautiful woman in her early twenties sitting at the other end of the carriage. We laughed and joked about "Wouldn't it be fantastic if she was the model instead of some Bessy Bradock." (Bessy Bradock was an amiable but pudding-faced, rotund, middle-aged politician, who, for a pair of teenage boys, had grown to symbolize the sexually unappealing.)

At college, we got into a conversation about the impending life class with Robbie, a big Scottish lad who was a couple of years our senior. According to Robbie, he'd been there, done that, and frankly didn't know what all the kerfuffle was about.

When the moment was finally upon us, we filed into the life room with our heads bent low and our smirks tucked carefully into the shadow of our collars. Needing a security blanket, I immediately went over and stood by my favorite easel. Steve took up a similar position on the other side of the room. Robbie, meanwhile, perched himself right next to me astride a donkey, a kind of long, low stool with a drawing board cradled at one end.

After a couple of minutes, our drawing teacher came in with, of all people, the beauty from the train. She had bare feet and was wearing a Chinese silk robe. It took me a few seconds to come to grips with the implications of this momentous occurrence. I shot Steve

a glance and could see that he was wearing a look of panicked ecstasy similar to my own. I snatched up a pencil and started sharpening it for all it was worth. (Funny: Back then, I never noticed how blatantly phallic that gesture was.) I was trying to compose myself, knowing that she still had to go behind the screen and undress. I told myself I had plenty of time to prepare for the oncoming shock to my senses. But, as it turned out, things didn't quite go the way I'd imagined. Our model's conversation with the teacher ended abruptly. Instead of stepping over to the screen, she simply pirouetted, and, with a flick of her delicate thumbs, unhinged the robe. Even without comparison, I knew I was gawking like a guppy at a truly celestial body. For long seconds the room filled with an unearthly silence. Then, from my right, there came a faint creaking noise that was followed by the awesome vision of Robbie's spasticated arms and legs beating in futility at the air as he and his donkey keeled over and crashed to the floor, spraying the room with a shower of pencil shavings, drawing board clips, and charcoal dust.

A RUDE AWAKENING

My years at Loughton had taught me the basics of drawing and painting. They had also instilled in me an idealistic dream of artistic brotherhood, so I left to attend senior college at Maidstone (a town fifty miles west of London) with hope and expectation abounding.

My rude awakening didn't take long.

There I was, unloading my materials from my case, when I noticed the stocky, bespectacled Liverpudlian next to me chaining and padlocking his easel to the ancient hot water pipes. In incredulity I asked, "Why're you doin' that?"

He replied in a caustic tone, "'Cause if I don't, some buggar'll nick it."

And he was right. Maidstone College was no artistic utopia. If it wasn't nailed down, someone would appropriate it. I'd have liked to have believed that this liberal distribution of

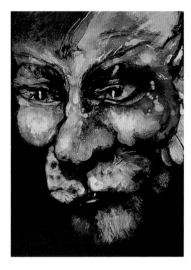

TOP LEFT: *The Icarus Splat* (1970) Wrestling with the vagaries of early acrylic paint was never easy. Later the medium became a lot more comfortable to handle— and the smell improved too!

ABOVE: In an attempt to drag images from my unconscious, this was one of three faces that more or less emerged out of the page. Black ink and white powdered paint. (1970)

property was a form of nonmaterial socialism. But it wasn't. This was *every man for himself*. San Francisco may have been flying high on ideals in 1967, but the inhabitants of the British art colleges that I encountered stuck to time-honored survival techniques.

A few of the other students turned up with the mind frame of bored factory workers. The neurotic ones like me, who did vaguely care about Art with a capital A, became insular and uncommunicative. Eventually, I lost my sense of purpose. I'd been trying to work semi-figuratively, but the arena was deserted. All around me I saw flat color canvases, masking tape, and minimalism. For a short while, I became one of those geometric sheep that I later had Griffin refer to in *Griffin & Sabine*.

The low point came one bitterly cold Christmas evening, with me sitting on a park bench just outside our little annex studio, across the river from the combined stench of Fremlin's Brewery and Sharp's Toffee Factory. Feeling unbelievably sorry for myself, I ruminated on the girlfriend I'd just lost, the turkey dinner I wouldn't be having (my father had a contract with a petrochemical company and my parents had been living in Teheran since I was seventeen), and the bloody stupidity of trying to be an artist in the latter half of the twentieth century.

Nineteen sixty-eight improved, slightly. Somebody showed me the *I Ching* and I bought a copy of Christmas Humphrie's *Zen Buddhism* (not that I embraced either of these fully, but they afforded me a glimpse of an alternative to swigging beer and bed-bouncing). A tutor even passed on a useful painting tip: to make black look darker, mix in a little Prussian blue.

I'd given up trying to be part of the system and had started to develop a contrary attitude. For our diploma exhibition, all of us were expected to formulate an obsession: something that would be the fenced-off area of art enterprise that we'd market in the real world. One student started painting flat close-ups of sections of cereal packets; another began making 6 x 6" white wooden boxes that she joined together in every combination she could mathematically contrive (if I remember rightly, she received first class honors). My approach was perverse diversity. I determined to make no two things remotely alike—I wanted them to seem as if they'd been created by different people. I guess I was parodying what I perceived as the futility around me (Duchamp was by now my role model). Needless to say, my earnest but supercilious attitude was not wholly appreciated by the assessors, and I passed only by the skin of my teeth.

My final piece before leaving Loughton College —one last picture to encapsulate my first two years as an art student: *A Homage to McVitie's Gingernut Cookies.* (1967)

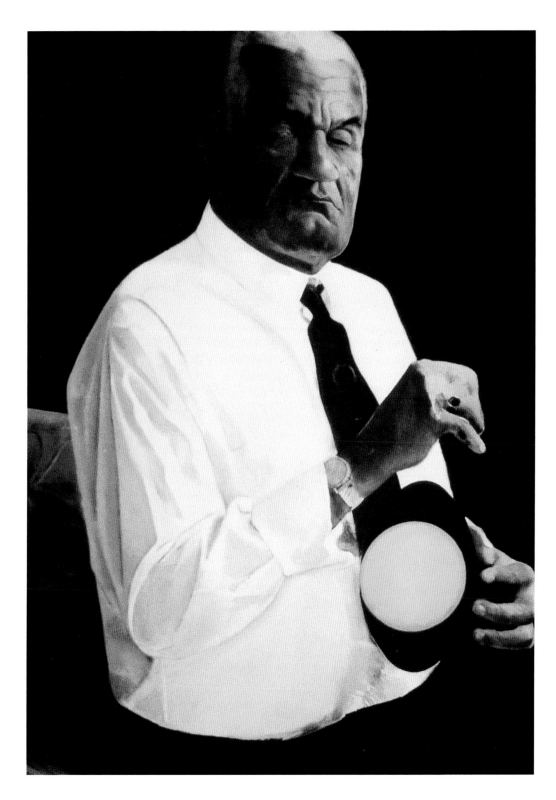

I kept this life-sized oil painting of a blind man holding a symbol of the universe in the tub in my bathroom, and one day a new girlfriend had a fit when she turned the light on and found that she wasn't alone in the room. (1967)

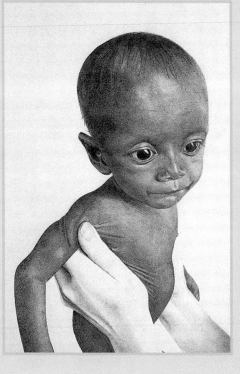

Book Covers & Illustration

PENGUIN INNOCENCE

Having finished my Save the Children commissions, I concluded that advertising agencies were a bit too hard-boiled for my artistic tastes. However, I liked the idea of earning money from drawing and painting, and decided to give editorial illustration a try. Book covers seemed a good start. So the following day, clutching my bag of drawings, off I went to Penguin. (I chose them, rather than any other publisher, because their logo seemed friendly.) Naiveté can sometimes be an asset: If I'd studied graphics instead of fine art, I would have known the complete preposterousness of starting at the top of the pile.

I arrived at the Penguin building, found the appropriate floor, and informed the receptionist that I wanted to see the art director. When asked if I had an appointment, I shook my head and was politely told that Mr. Pelhams, the art director, only saw new artists on Thursdays, and then only by appointment.

"It is Thursday," I said, realizing that my timing was okay, even if my sense of protocol wasn't. The receptionist just smiled the smile that people in authority give you when they know you haven't got a hope in hell of getting past them.

It was at that point that David Pelhams came loping down the corridor saying, "Helen, has that ruddy artist turned up yet?" Then, stopping to look at me, he asked, "Who are you?"

I replied, "Um, I was hoping you'd look at my pictures."

To which he retorted, seemingly not caring who filled the slot, "You'll do. Come on in."

While I laid out my drawings, I babbled and he pretended to listen, though it was obvious he was practiced at tuning out the pointless monologue that I've since realized issues forth from the lips of almost all inexperienced freelancers. Eventually he held his hand up for me to desist, pondered a second or two, then pulled down a manuscript from his shelf and passed it to me, saying, "Richard Marius. *Coming of Rain*. Bring me a rough in two weeks."

"Sure," I said.

And that was how I became a cover illustrator. No pain, no torment, just timing. Of course

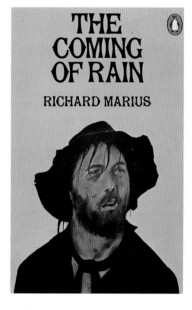

ABOVE: My first book cover. I was a bit concerned that the guy looked too much like Dustin Hoffman, but I needn't have worried, because everyone thought it was Robert Mitchum. (Early '70s)

FACING PAGE: One of the Save the Children Fund drawings that got my illustration career started. (1973)

A section of the illustration for *Drummer in the Dark* by Francis Clifford (Meulenhoff). An example of blending colored pencil and graphite. (Late '80s)

that was only phase one. I still had to read the book, come up with an image, produce the finished art, and get it approved. In reality, my struggles had barely begun, but at least for a short while, I basked in the glow of good fortune.

OTHER PEOPLE'S BOOKS

Between 1972 and 1990 I earned my living as an illustrator. I can't say it was always romantic, but it was a lot better than pumping gas.

Book covers were my mainstay, and I probably did well in excess of three hundred during that period. I managed to avoid getting pigeonholed into specializing (the majority of illustrators find it easier to concentrate on one particular genre, thereby getting a steady stream of commissions). I tended to get the books that art directors didn't know what to do with. I'd finish a commission, take it in, and then sit gossiping (I loved hearing what was going on in the publishing industry). Finally he or she got around to thinking about their new book list. Then they'd get up and poke around on a shelf of manuscripts or hardcovers until they found something odd. "What's this bloody thing about? Can't understand a bloomin' word of it. Here, Nick, do us a cover for this. You can figure the friggin' thing out."

So I ended up doing my own art direction as well as the illustration. And for some reason, the art directors trusted me, even though they hadn't a clue whether my choice of image made any sense whatsoever. And the range of subjects I got to work on was huge, from erudite texts on psychology, like Bruno Bettelheim's *Freud and Man's Soul* to Flann O'Brien's *The Third Policeman*, a marvelously surreal story that includes characters such as the police constable who thinks he is a bicycle.

I tried very hard to be professional and do as good a job on the dross as the quality writing, but it was tough. When a book is badly conceived, horribly structured, and goes nowhere, there's a mighty powerful temptation to warn the public with some kind of visual clue (like a skull and crossbones). I'd get frustrated at times but, looking back, reading such a broad expanse of literature undoubtedly helped me when it became my turn to write.

To stop myself from getting bored with cover work, I developed a private agenda. I'd give the publisher what they needed and I'd paint the picture I wanted, using the themes and private narratives that governed my world—a stone angel from Highgate cemetery, monastic calligraphy, skull X rays, a double-headed portrait of Duchamp, a girlfriend sitting on a sofa, and anything else that took my fancy. I also used as many different combinations of media as I could in an attempt to keep expanding my craft. To me, style wasn't a signature, it was simply a tool to gain control over the specific atmosphere I was after.

Books were my prime revenue source, but I also designed and illustrated London West End theater posters like Tom Stoppard's *Dirty Linen* and Alec Guiness's *Yahoo*, as well as fringe

publicity for the all-women's theatre troupe Cunning Stunts (not to be said carelessly). I did a whole mass of trade record covers for a music company. I illustrated for all sorts of magazines from *Psychology Today* to *Seventeen,* and even *Men Only.* The last required some sprightly mental gymnastics because, being genuinely supportive of the feminist movement, I had to justify to myself and my female friends the reason why I was working for a girlie publication. I solved the problem by announcing that I would execute a nonsexist painting, which I pointed out wouldn't be the case if someone other than me did the picture. In truth I did it because I needed the money badly and I was getting a bit fed up with the strident dogma that snapped at the allies as violently as the enemy.

Toward the end of my time on the graphic war-front, I started to get tired and jaded. I was finding it hard to listen to a new breed of hands-on art directors say things like, "Maybe if the shirt was purple instead of blue." Or, "I was thinking it might be interesting to have a picture of the inside of a freezer." When I finally bowed out and pursued my own books, it was probably just as well, because I was getting dangerously close to committing some serious act of sabotage—like the Burmese engraver who inscribed obscenities into the foliage of a Japanese occupation banknote during World War II.

FOOTLOOSE

Eighteen years is a long period in anyone's life, and inevitably, even though I was doing the same job, a great number of changes occurred. For starters, I moved from Buckhurst Hill on the far end of the London underground to Oxford, and from there to central London, where I found myself batted from house to house to house, as landlords sold property without notification, buildings were condemned, and the mice who lived in the cereal boxes and the cooker got a little too self-assured. By then I'd had enough of playing musical metropolis and took off for the Herefordshire countryside. I stayed in an old house endearingly called The Blue Frog for three years before gravitating back to another city. This time it was Bristol in the southwest of the country. When I finally broke free of the English shores and moved to Canada, I was a married man with a young son.

As for my commissioned work during this time, it wore numerous faces. At one point, when I didn't have enough income, I took on an alias and started doing science fiction illustrations under the name of Nick Fox. Most of the pictures leaned too heavily on Frank Frazetta to be considered interesting, but they paid the way and the cat stayed fed.

Coming up with new covers became more and more a problem-solving exercise: finding different ways of defining the tone and the content without slavishly mimicking the words. That's when I started to comprehend that image could function in equal partnership with text, rather than as its servant—an insight that would grow and become the foundation of my own books.

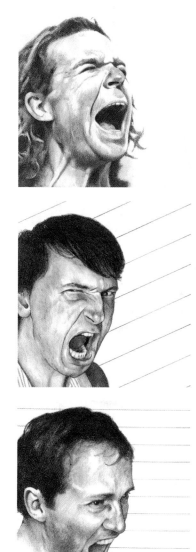

Three preparatory drawings for a ghost story. I've since forgotten the book's title! I asked each of the guys I shared a studio with to scream. The ease with which they performed the task presumably reflected the difficulties of earning a living as a graphic artist. (1989)

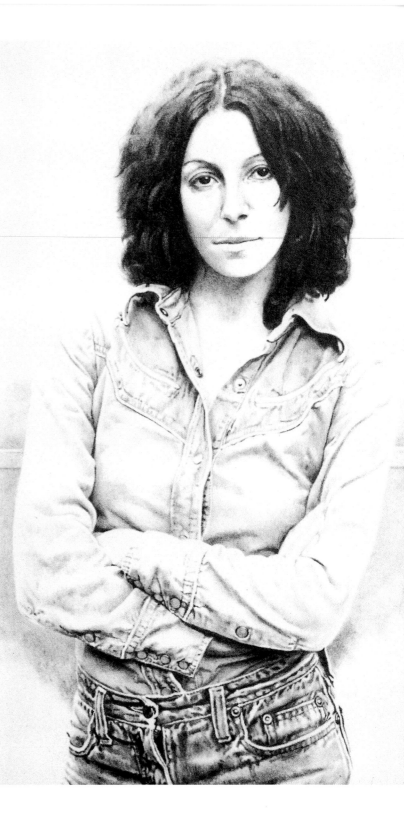

THIS PAGE: Three drawings from 1976–77: Quite early on I discovered that the secret to getting a really tight graphite drawing is to work the surface up through the pencil grades (HB, B, 2B), gradually increasing the darker tones.

Often a preparatory drawing, like the Band-Aid sketch above, would only take half an hour. But in the case of a highly finished drawing, like the young woman with folded arms, it could take days. I remember spending three hours on the inch-long section between the jean's belt loops.

THIS PAGE: These two Save the Children
Fund drawings (1973) were done in single sit-
tings, at the dining room table. They both
took about twenty-four hours, and the only
times I allowed myself to get up were for
bathroom breaks and to replenish my bowl of
cornflakes.

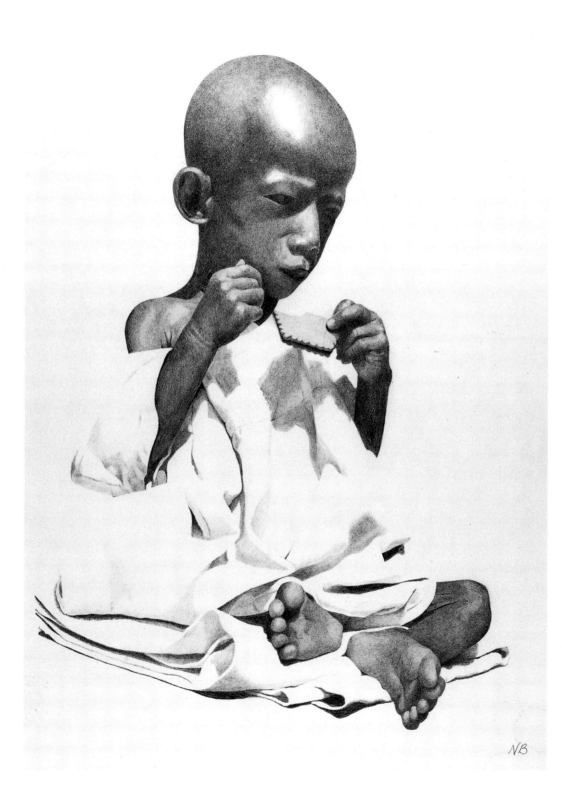

For a while my parents lived in Holland, and
when I visited them, I would occasionally
pick up and deliver a book cover commission
from the Dutch publisher Meulenhoff.
(Late '70s)

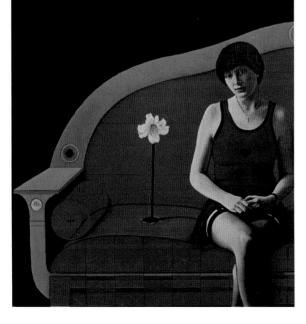

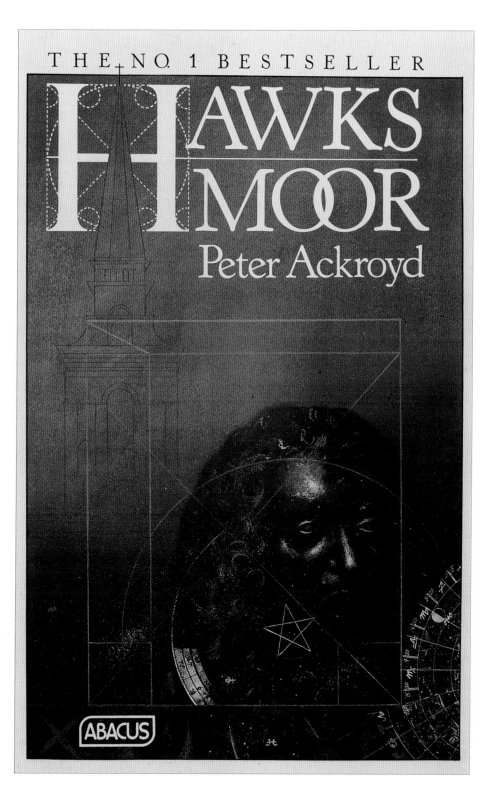

Two of my better covers. Later I combined the images from *Hawksmoor* (mid-'80s) and *The Third Policeman* (early '70s) to make one of the cards in *Sabine's Notebook*.

FOLLOWING SPREAD: Twelve samples of the three hundred-plus covers I produced while living in England. Because I wasn't limited by genre, I had more than ample freedom of style. (Mid-'70s to mid-'80s)

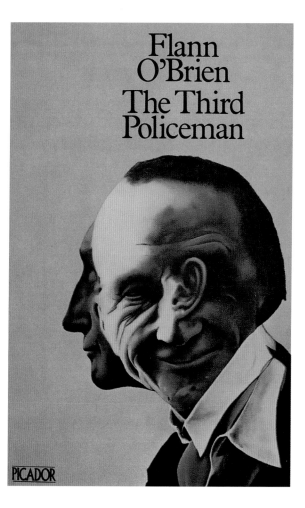

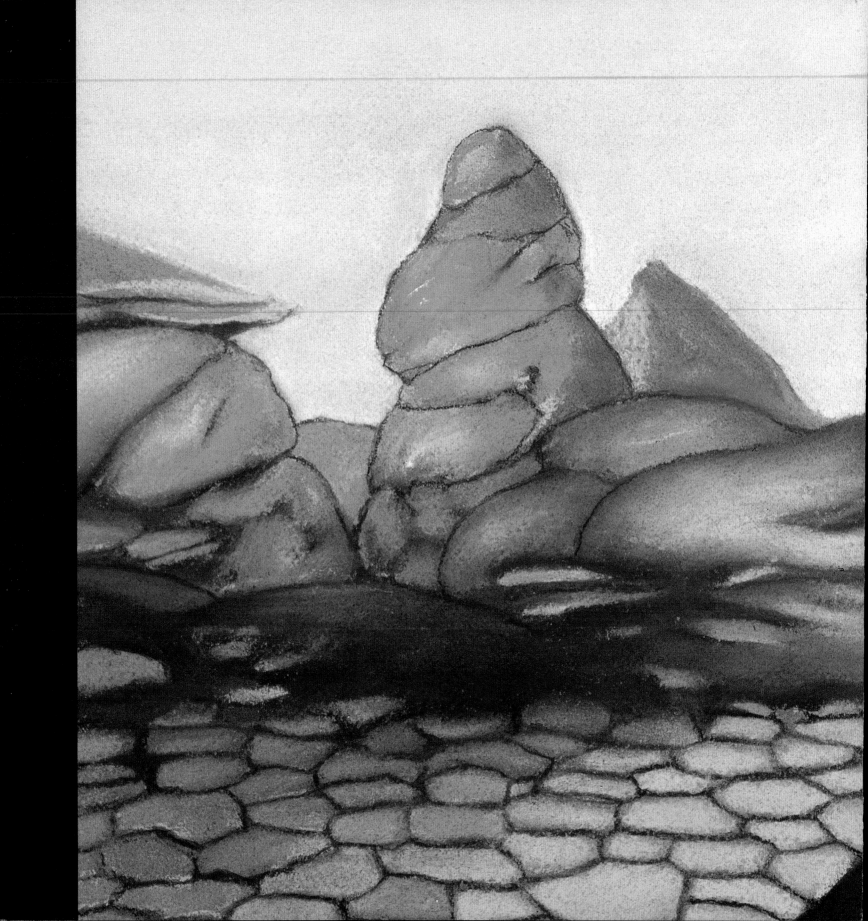

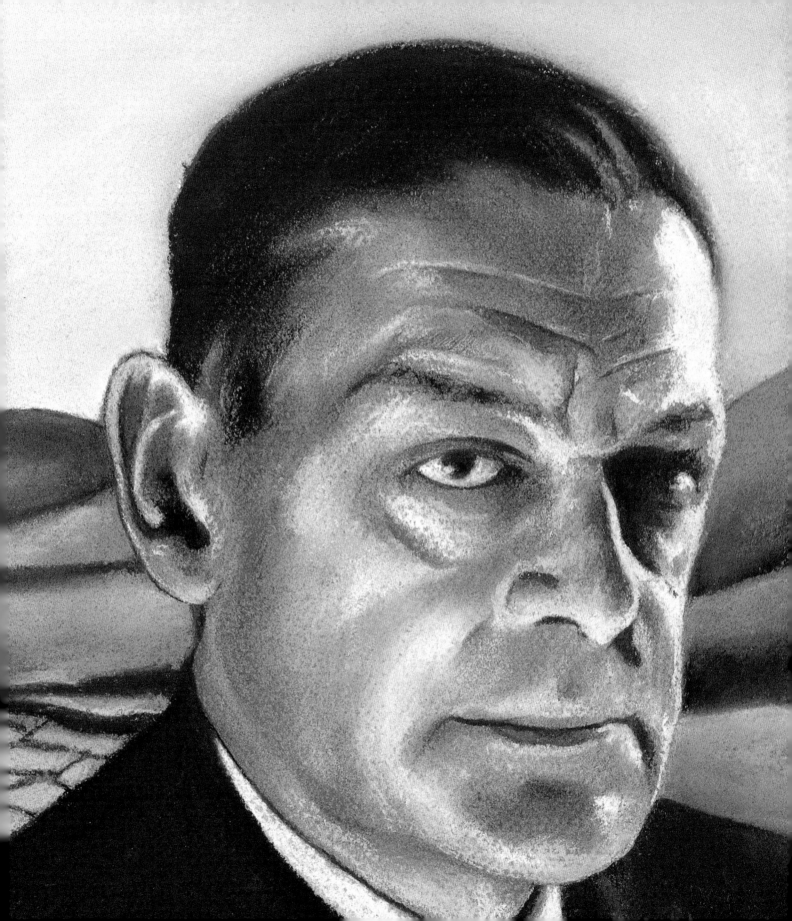

PREVIOUS SPREAD: Chalk pastel drawing
of T. S. Eliot for Peter Ackroyd's book on the
poet. The landscape was intended to represent
Eliot's Wasteland. (Late '80s)

THIS SPREAD: Under my alias, Nick Fox, I
did a few science fiction covers. I'd read sci-fi
'til it came out of my ears when I was a teen.
Working on these covers was an act of pure
nostalgia. (Mid-'70s)

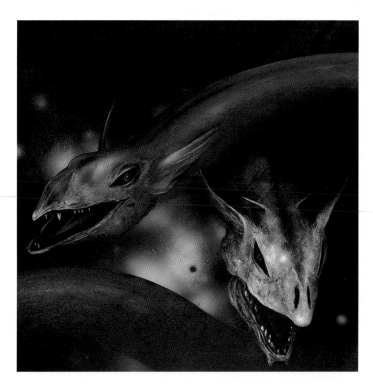

THIS SPREAD: My first inclination was to turn down a commission for a series of horror books, but then I decided it might be an interesting challenge to try to do them avoiding any use of blood, skulls, or sharp implements. I made no preparatory sketches, just piled in and watched them chew and claw their way out of the panels. (Early '8os)

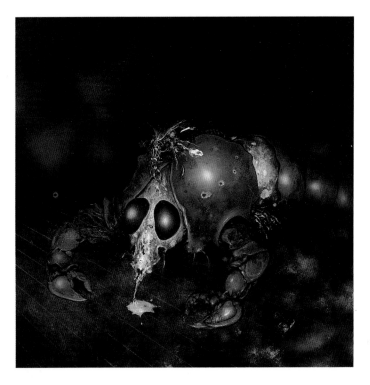

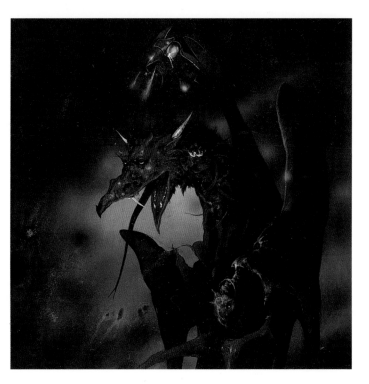

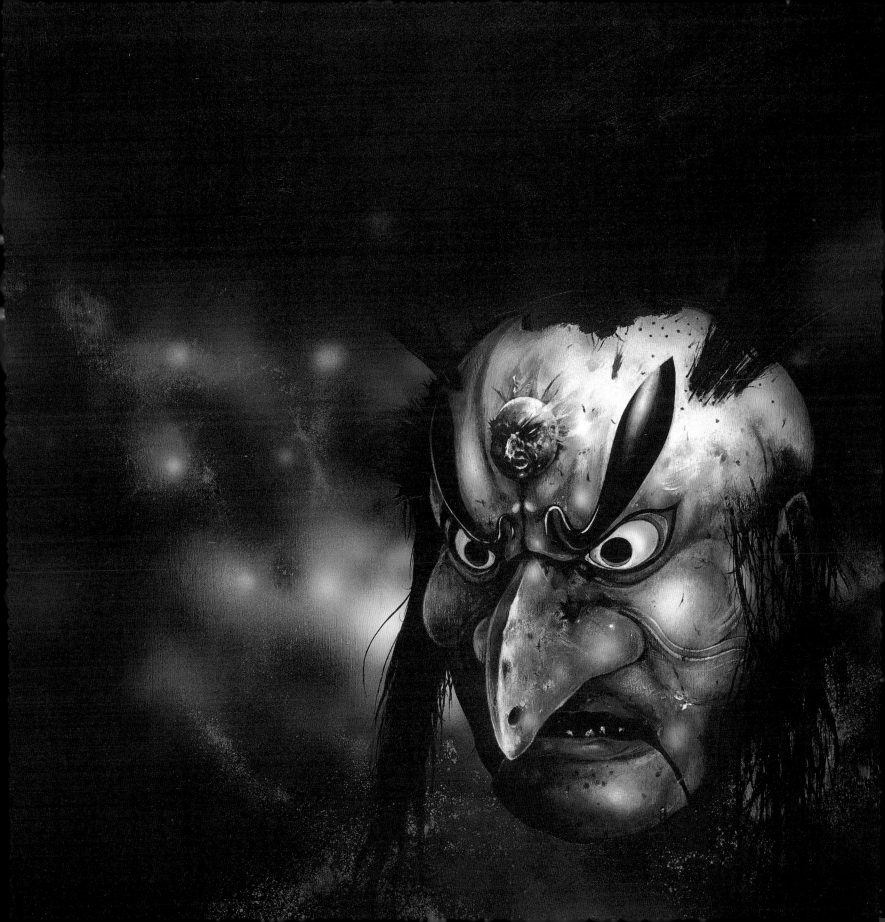

RIGHT: Deadlines often affect the technique and material used in a picture. I had exactly one month to come up with fifteen illustrations for the interiors of *The Complete Astrologer*. I chose acrylics on illustration board as the fastest means to produce reasonably substantial images. (Mid-'80s)

BELOW: A pair of magazine illustrations in which I attempted a slightly looser oil painting technique. (1975)

LEFT: *Keeping the Wolf from the Door* (1987)
An illustration for a book on dream interpre-
tation.
BELOW: My less than subtle poster design
for the London theatre production of Tom
Stoppard's *Dirty Linen*. (1975)

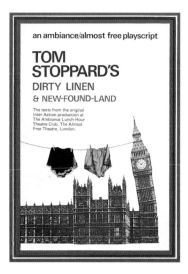

Painting

FLAILING AROUND

During my early twenties I was passionate but directionless, and I was determined to keep painting and illustration in separate categories. I believed that commercially commissioned art was tainted and that it couldn't be equated with what I considered soul food. Illustration paid my way but, as a painter, I wanted to belong to the history of art and artists. It wasn't all delusions of grandeur; I really did desire that honorable artistic fellowship I'd dreamt of at college. This separation between commerce and purity was an odd stance, because the artists I aspired to had made their living by their trade. I probably had as much scope doing a picture for a book cover as, say, Caravaggio working for the church, or Rembrandt knocking out a portrait for a wealthy burgher. Pompous as I was about high art, I was still stringent in my illustration craft. I stuck strictly to painting fundamentals, never condoning the use of illustrative techniques such as arbitrary use of color or superficial or decorative marks. It was a strange contradiction: Half the time I was painting I could allow myself to call it painting and the other half I couldn't, even though the physical activity was the same.

Nineteen seventy-seven heralded my last attempt to keep apart the worlds of painting and illustration with a series based on the theme of the four seasons: eight paintings, on 6 x 4' wooden boards, showing figures in landscapes. The cycle was an attempt to represent a metaphysical relationship between emotional weather and the environment. It was supposed to be monumental but, like most art born of idea alone, it lacked conviction. When I eventually admitted to myself that the pictures were not very good, I was forced to accept one of the fundamental truths of painting—art has to be grown, not built.

By the early 1980s my work had become stagnant. I'd gotten tighter and tighter, and began feeling suffocated every time I picked up a brush. My breathing became so shallow while painting that when I stopped it seemed like I was hyperventilating. I was squeezing myself so hard that my pictures were choking to death before they could come out of me.

I had begun to study to become a psychotherapist (one year later I gave up, for reasons of

ABOVE: Shiva study for the four seasons cycle. Many years later it would reincarnate within *The Venetian's Wife*. (Mid-'70s)
FACING PAGE: Mostly my nonfigurative paintings are exactly that, but every now and again something appears out of the slime—like this fish from 1983.

psychological self-protection) and didn't know whether to stop painting altogether or just to plough on. I thought of Carl Jung's line about there being no creativity without play, and decided that I was too obsessed with the idea of getting things right. I needed to give myself permission to make a mess. So I bought a box of cheap chalk pastels, pinned two very large sheets of paper to the wall, took a pastel in each hand, cleared my mind of any preconception, and began flailing around for all I was worth. I kept at it for three or four hours, refusing to let myself stand back and look at what I was doing. I didn't want to start making aesthetic or compositional judgments. I just wanted to let rip. The release I felt at using my whole arms instead of just my fingertips was exhilarating. And the physical tiredness seemed nothing compared to the mental strain I'd been placing on myself for years. I had fun. And when I did finally stand back, I was amazed to discover that a far more personable kind of art had emerged.

After the chalk pastel extravaganza I switched to working on the floor. Being able to circle a picture, then drop down onto it from any angle, gave me more freedom. I noticed how it opened up many options of both control and random occurrence. I also began to use metallic powders floated in clear acrylic bases. I was painting again in earnest, though this time with a much looser attitude. I set aside the richer colors of oil paints and went over to acrylics, which were faster-drying, but more acidic. To compensate for the color changes, I reduced the brightness of my palette, limiting myself to ochres, sage and hooker greens, lacquer reds, dioxine purple toned down with black, and occasionally cerulean blue. Using paper and wood panel as a ground, I tried attaching sections of fine muslin to the ground, dragging dry scumbled paint over the textured surface, then laying watery glazes on top.

These and other experiments taught me a new language of brushless painting and helped me develop the chaos that would counter my sense of ordered composition. By then I was also starting to use these techniques in the book cover commissions. The gap between painting and illustration was closing rapidly.

ABOVE: *Black Spring* (1977)

FACING PAGE: *White Autumn* (1977)

Two of the large season cycle paintings just before I abandoned them for good.

UNDER THE INFLUENCE

It's a complicated matter, trying to pinpoint the people who have significantly influenced us. In terms of painting, I'm unclear, because my perception of general historical importance (a nonpersonal overview) gets confused with my own mythology (a personal collection of meaningful characters). Also *influence* can refer to longevity or to intensity. For example, when I was nineteen I was infatuated with Rauschenberg's pictures, but by twenty my crush had cooled. On the other hand, it took decades to see how significantly I'd imbibed the compositions of Vermeer and Piero della Francesca. Francis Bacon's technique fascinated me, though I never felt any direct influence; whereas Gauguin's paintings seemed troublesome, like a smart man

whose trousers are too short—yet repeatedly I return to him for encouragement, because he could make awkwardness graceful.

I was very lucky, living in or near to London, to have access to the big galleries, like the National and the Tate, as well as to the numerous private galleries in and around Cork Street. I was able to spend intimate time with hundreds of the great paintings that most people only get to see in books.

So, when the dust has settled, who stands out?

Cézanne I copied brick by brick, trying to understand how to trust his internal golden mean. The lux twins, Turner and Monet, were both beyond my comprehension—I'd stare at their pictures for hours hoping something might rub off on me. Rembrandt (Mr. Glaze and Impasto) taught me that a sculptural battle has to be waged even on the two-dimensional surface. Leonardo (alias Merlin) was my boyhood hero, at first for his inventions and later for his drawings. If I could own just one of the world's great artworks, it would be his cartoon of *The Virgin and St. Anne*. Morandi counseled patience, tenderness, and dignity. Cornell's boxes gave encouragement to collect the objects that intrigued me. Duchamp the Joker was always two jumps ahead of the game, never letting anyone see quite how (un)serious he was. Chagall annoyed the hell out of me: His early work was so good, so intense and personal, and yet he allowed himself to slip into syrup. Why couldn't he have listened to Picasso? "Copy anyone but yourself." Then there was Rothko and the great maroon room at the Tate gallery: Stepping in there felt like being sideswiped by a truck the size of Chartres Cathedral.

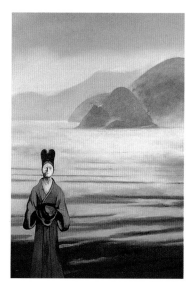

Guts, power, compassion—it's all there. I just wish I could take a simple delight from it, but I can't, because I really have become the Artful Dodger, the rogue scavenger who borrows the shining things before they're lost.

Recently my attentions have drifted away from Western painting: I react more strongly to things like Hermetic engravings, Hindu sculptures, Japanese armor, or old maps. Influence is a flighty muse, coming and going by its own rhythm.

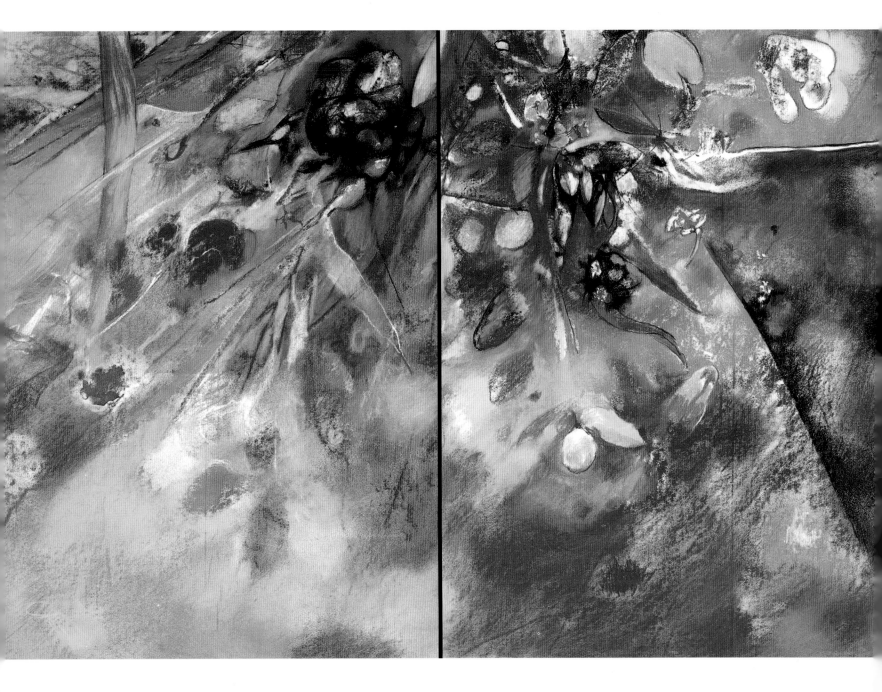

A chalk pastel quadratych (1981) done using both hands at once. There's probably Odilon Redon influence somewhere in here.

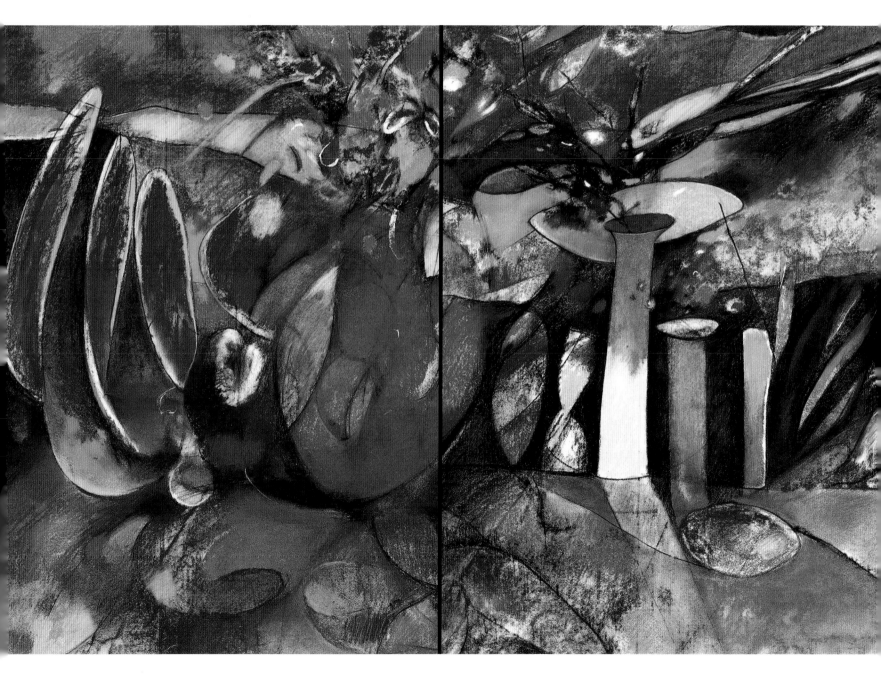

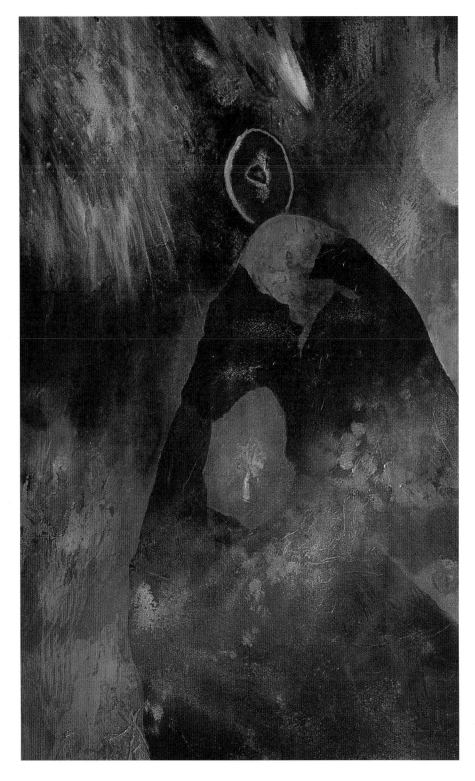

THIS SPREAD: Once I loosened up and started to paint more freely, the paintings came thick and fast, big and small. While I was working on them, I had no reference or subject matter in mind. Only afterward did I notice groupings like the three *Mountain Pictures* on the facing page. (1983–84)

Quadratych (1988) The last painting completed in England. I'd started to experiment with a darker palette. I wasn't conscious of a mood change, just thinking in earthier tones.

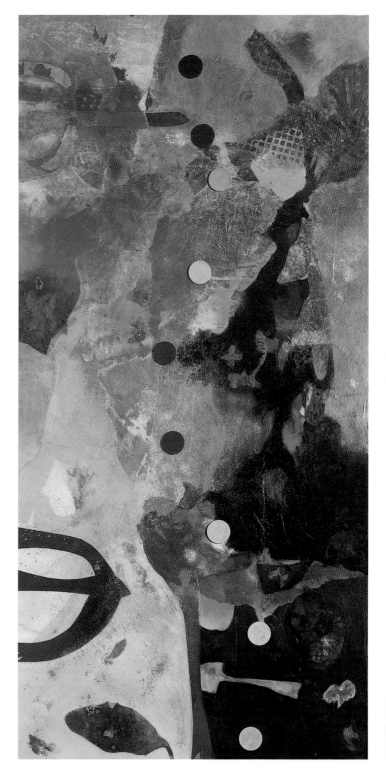

THIS SPREAD: Tissue paper and metal powders became part of my armory of materials, and both brought an element of chance to the paintings.

My method of application continued to change. I was working on the floor so that I could walk around the piece. Also I was using brushes less and less, often painting with my fingers. (1985–86)

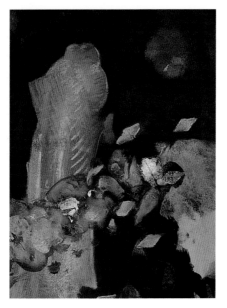

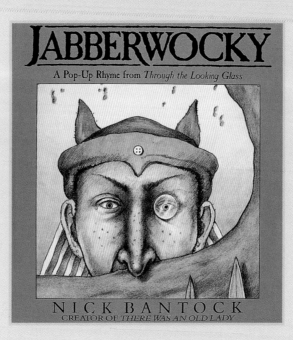

Pop-Ups

PERMISSIVE LIGHTBULBS

Living in Thatcher's England in the eighties was no joy, unless you were one of the top seven percent of the population who owned ninety percent of the country's wealth. There was a general air of hopelessness and despondency, and anyone foolish enough to try and innovate was perceived as acting above their social station. By 1988 it had become unbearable. I hated the idea of my young son growing up in that oppressive atmosphere. So we sold our possessions and jumped continent.

For me, North America was a revelation. I'd never actually experienced vocal encouragement before and I'd certainly never had anyone say, "Great . . . go for it." I felt like I'd grown wings. It's true that being given work is a form of encouragement, but in my experience there's a crucial difference between being acknowledged as competent and being openly told that you are good at what you do. It's the difference between passive and active acceptance that matters so much to the hungry child within us.

About a year after moving to Canada (my parents were living in Calgary, and a short visit with them had been enough to encourage us to emigrate), I received a phone call from David Pelhams, the Penguin art director who'd given me my first job. He and I hadn't spoken since the early seventies, and in the interim he'd moved to the United States and authored the best-selling pop-up book *The Human Body*. He was looking for someone to work on his most recent project and wanted to know if I'd be interested. I said that I knew nothing about pop-ups, but he assured me that I could learn as I went along. So I flew down to L.A. and met with him at Intervisual, the pop-up book packaging company, and after a lengthy discussion, agreed to participate. The project had a rocky history; David and I didn't always see eye to eye; and eventually the book expired, but I found myself enthused by his entrepreneurial attitude. I remember sitting in a hotel lobby talking with him about his books when suddenly a little lightbulb came on over my head: "If he can do it, so can I."

Having in that instant granted myself the permission to move from being a service industry

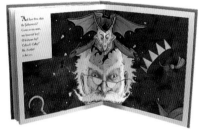

ABOVE: A spread from *Jabberwocky*—the reincarnated Jabberwocky bursts from the father's head. This was a personal and less conventional interpretation of the poem's ending. (1991)

FACING PAGE: Cover for the Lewis Carroll nonsense poem.

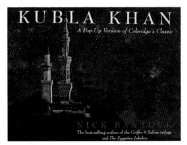

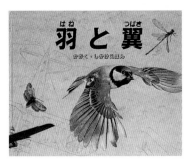

ABOVE: Covers from Samuel Taylor Coleridge's *Kubla Khan* (1994) and *Wings* (1991). *Wings* came about when I was looking for source imagery of angels' wings. The library had no generic books on wings, so I decided to create one of my own.

FACING PAGE: *There Was an Old Lady Who Swallowed a Fly*. After swallowing the fly, the bird, the cat, the dog, and the horse, her condition became terminal. (1990)

to instigating my own books, I returned home to set about working on an idea for a pop-up version of the World War I playground rhyme *There Was an Old Lady Who Swallowed a Fly*.

Describing the decision to change my career sounds matter-of-fact, but in reality it was a huge jump. I was leaving the relative safety of freelance commissions for the turbulent waters of authorship. And as exciting as the prospect might have been, I knew that I was putting myself and my family's finances into an even more precarious position.

Fortunately, Intervisual liked my *There Was an Old Lady* proposal, and it was the beginning of a productive relationship that saw me do a further six books with them: *Solomon Grundy, Robin Hood, Jabberwocky, The Walrus and the Carpenter, Kubla Khan, Wings,* and *Runners, Sliders, Bouncers, Climbers* (the final one being far and away the worst title I've ever come up with!).

A packager like Intervisual works with an author to produce a book. When the book gets to the dummy stage it is then sold to a publisher. Fortunately for me, *There Was an Old Lady* was picked up by Viking, which initially intended to publish it as a children's book. But the Children's Department thought it was too frightening (I think they meant in bad taste), so it ended up being published by the adult division (as have all my small pop-ups). Of course, the stores put the book straight onto the children's shelves—where they were merrily purchased by young and old alike.

Things are better now, but for a while it seemed like there was a Puritanism running through children's publishing that bore no resemblance to reality. Kids were thought to be unable to separate the mildly gross from the debauched—to my mind, a horribly patronizing attitude. My children adored Roald Dahl, and they had no problem separating out his diet of squashed worm sandwiches from their real dinner. Fortunately, the socially correct tourniquet around kids' books seems to be easing, but a new Big Brother has arrived on the scene. One that says, "We mustn't frighten the children with long words and complexity." It's curious to note that a first-time submission of *Alice in Wonderland* would probably be passed over by the majority of present-day children's publishers, and Lewis Carroll would be piling up those little rejection slips. It really shouldn't be a matter of choosing between Grimm and bland, but as long as we underestimate our children as much as we overstimulate ourselves, we will reap the inevitably unpleasant rewards.

I believe it's absolutely correct to protect children from adult excesses, but my four kids have taught me a great deal about their world and, in so doing, have helped me remember what I enjoyed as a child. They've been my guide, and I've gained more from watching them paint and draw than I ever learned at art college. Children are smart, and they understand fantasy far better than we. They know that farting crocodiles are more pleasing than politically perfect parrots.

PAPER CHASE

I taught myself how to construct pop-ups by trial and error; using scissors and a roll of Scotch tape. I began with simple cuts and folds; then, when I'd gotten the hang of the easy stuff, I started dismantling any old pop-up books I could get my hands on to see how the more complex paper mechanics functioned. I'm not good with car engines or metal mechanisms, but somehow working in paper felt manageable.

Messing about and learning how a basic pop-up works was one thing; completing the full process from idea to finished book was a very different kettle of fish. Here's a blow-by-blow account of the practical process, taken from an article I wrote for the *Los Angeles Times:*

Having picked my subject, I begin with a series of scribbles that transmogrify themselves into a set of graphite drawings, one for each of the six spreads. [Using more than six spreads is not uncommon but, in terms of cost, the number of glue points available is limited, and to get a reasonable degree of complexity into the mechanics, these points have to be apportioned fairly evenly over the spreads.] I photocopy them in black and white, glue them to thin card, then begin snipping and hacking with scalpel and scissors. After that, I start bending, folding and sticking bits together with a glue stick or double-sided tape. The result is ugly, but it gives me a sense of where I'm going.

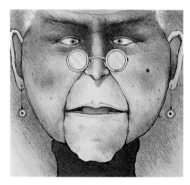

If I'm happy with what I've come up with, I glue the pages together to make a full dummy, then send it to the paper mechanic (the paper mechanic is to me what the Grand Prix racing mechanic is to the garage guy who tinkers with engines).

Over the next month or so, the mechanic will turn my inexactitudes into fine, smooth-running paper chases. A white-card version is sent back to me. I play at making further cuts and once again the mechanic refines. If all is well, I receive a large sheet that has the various pop-up parts opened out flat.

Then comes the tricky bit. I have to produce the color art to fit these higgledy-piggledy squashed-out templates. It requires a little retraining of the brain, not unlike a printer learning to read metal type backwards.

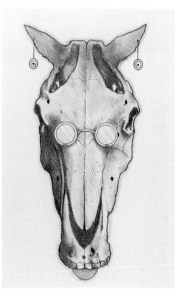

When I've completed the art, the paper mechanic color photocopies it and rebuilds the devices yet again. I then make my last changes to both the art and the cuts. Color separations are made, and the jigsaw-like nesting sheet is finalized. Then away it goes to a printer in the Far East or Colombia, with a wing and a prayer.

After a while, the proofs come back and small adjustments to the color and die cuts can be made, but mostly what you did is what you get.

'Twas brillig
and the slithy toves
Did gyre and gimble
in the wabe:
All mimsy were
the borogoves
And the mome
raths outgrabe.

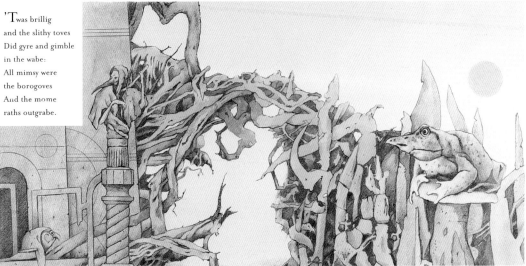

I

"Beware the Jabberwock,
my son!
The jaws that bite,
the claws that catch!
Beware the Jubjub bird,
and shun
The frumious
Bandersnatch!"

He took his vorpal
Sword in hand:
Long time the manxome
Foe he sought—
So rested he
By the Tumtum tree,
And stood a while
In thought.

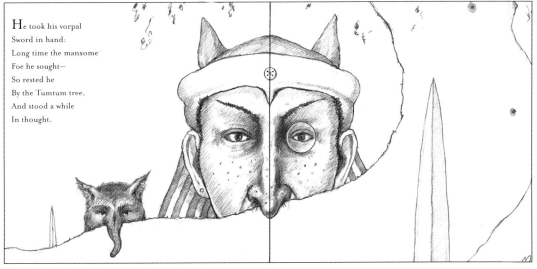

3

2

When I was in my second year at art college, the students below us were given the project of illustrating *Jabberwocky*. They seemed to have such a good time I was quite jealous. Years later when I started doing books of my own, I took the opportunity to indulge my past envies. (1991)

1: The slithy toves gyring and gimbling.

2: The father utters his warning to his son, hooked hand raised to emphasize the dangers.

3: The intrepid hunter and his sidekick (vorpal swords in hand) go looking for trouble.

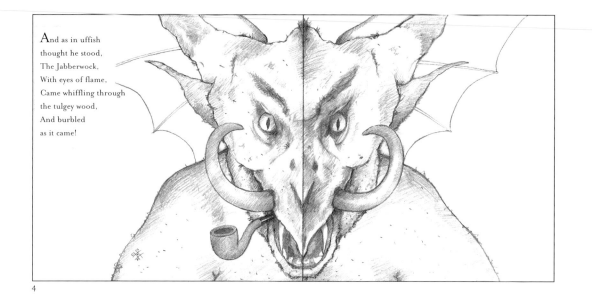

And as in uffish
thought he stood,
The Jabberwock,
With eyes of flame,
Came whiffling through
the tulgey wood,
And burbled
as it came!

4

One, two! One, two!
And through and through
The vorpal blade
went snicker-snack!
He left it dead,
and with its head
He went
galumphing back.

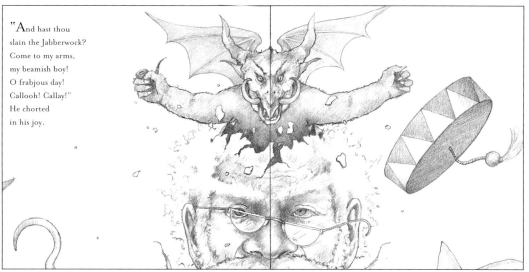

"And hast thou
slain the Jabberwock?
Come to my arms,
my beamish boy!
O frabjous day!
Callooh! Callay!"
He chorted
in his joy.

6

5

4: The Jabberwocky whiffles into view. The pipe idea came from ex-British Labour Prime Minister Harold Wilson.

5: The son, wearing odd socks, drags off the severed head.

6: The reborn Jabberwocky emerges from the unfortunate father's skull. (In some Eastern cultures, a figure bursting out of a head represents a great insight.)

I

The sad and pathetic tale of Solomon
Grundy. Poor Solomon is born during a
storm and can only watch as the weather
gradually improves while his health takes
him downhill into the grave. I embellished
upon the traditional verse and added the new
Mrs. Grundy.

2

Solomon Marmaduke Fortescue Grundy
born on a black and beastly Monday.
Christened on a stark and stormy Tuesday.
Married on a grizzly Wednesday.
Ill on a mild and mellow Thursday.
Worse on a bright and breezy Friday.
Died on a gay and glorious Saturday.
Buried in a baking, blistering Sunday.
This is the end of Solomon Grundy.

3

4

5

THIS PAGE: *Robin Hood.* Master Hood is alone and bored in Sherwood Forest. So he entertains himself by dressing up as Maid Marion, Friar Tuck, the Sheriff, and the rest of the Merry Men. In the last spread he heads home to tea still wearing the remnants of his disguises. (1993)

FACING PAGE: In *The Walrus and the Carpenter*—a classic tale of betrayal—the two protagonists devour their oyster traveling companions. Whilst drawing the walrus, I kept hearing the voice of John Lennon in the back of my head. (1992)

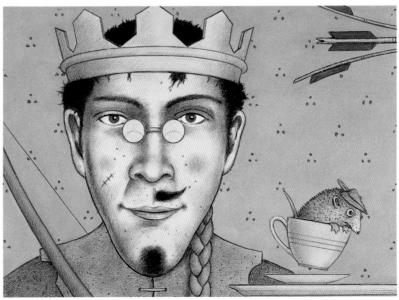

"A loaf of bread," the Walrus said,
 "Is what we chiefly need:
Pepper and vinegar besides
 Are very good indeed—
Now, if you're ready, Oysters dear,
 We can begin to feed."

"But not on us!" the Oysters cried,
 Turning a little blue.
"After such kindness, that would be
 A dismal thing to do!"
"The night is fine," the Walrus said.
 "Do you admire the view?

"It was so kind of you to come!
 And you are very nice!"
The Carpenter said nothing but
 "Cut us another slice.
I wish you were not quite so deaf—
 I've had to ask you twice!"

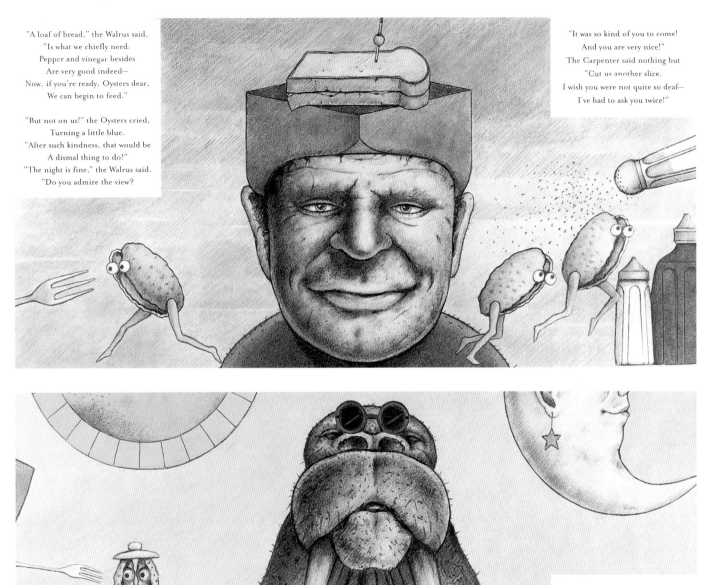

"It seems a shame," the Walrus said,
 "To play them such a trick.
After we've brought them out so far,
 And made them trot so quick!"
The Carpenter said nothing but
 "The butter's spread too thick!"

"I weep for you," the Walrus said:
 "I deeply sympathize."
With sobs and tears he sorted out
 Those of the largest size,
Holding his pocket-handkerchief
 Before his streaming eyes.

"O Oysters," said the Carpenter,
 "You've had a pleasant run!
Shall we be trotting home again?"
 But answer came there none—
And this scarcely odd, because
 They'd eaten every one.

Griffin & Sabine

FIRST POST OFFICE STORY or
THE BIRTH OF GRIFFIN & SABINE

On a gruesome February morning in 1990, I went down to our local friendly post office to collect my mail. Inside the small building there were a couple of my island compatriots, keys in hand, about to retrieve their post from the bank of silver boxes that lined one wall. While I was liberating my ugly brown bills and useless gaudy circulars, I noticed that the person in front of me had plucked out a plum—a hand-addressed, blue airmail letter complete with a large tropical stamp. I uttered something to the effect of "Lucky sod," and the woman beside me, who obviously shared my sentiment, echoed, "It's not fair, is it?"

As I started up the road I was muttering to myself, "How come I don't get mail like that?" And the answer came back: If you don't send letters, you won't get replies. I mused, "I suppose *everyone* wants the perfect letter." It was a train of thought that could easily have ended there, but I've done far too much therapy for my own good, and I began toying with the peculiar notion of writing letters to myself. I considered, What would make the perfect mail? I surmised that it would need to be colorful, exotic, mysterious, romantic, and even prophetic. An hour or two later, I wisely decided that it would probably be saner if the letter I was thinking of writing were addressed to someone other than me.

On further reflection, I thought a one-sided correspondence wouldn't be enough. Anyone receiving a letter containing all those special properties would have to respond. In which case, I would have to create mail going both ways. And if I was going to do that, I might as well go the whole hog and turn the thing into an epistolary story.

I mulled it over for a couple of days and decided that an imaginary correspondence could tie in with something else I'd been thinking about. Running through the hundreds of paintings and drawings that had spilled out of me over the years were a number of themes, both visual and philosophical. Some of the art had been for book covers, some for its own sake, so I'd never really properly linked them together. If I included postcards in this fictitious exchange

of mail, then I could sew together the threads of all those ideas and images that had preoccupied my adult years.

It was beginning to fit together nicely, but there was still something missing from the mix, and it had to do with the jealousy I'd experienced in the post office around the envelope itself. One of the key pleasures of receiving a letter is the act of holding and entering an envelope—a sort of cross between Christmas and sex. What better way, I thought, of reproducing that physical sensation of expectation than providing the book's reader with the chance to open the envelope themselves? Having been involved with the complexities of pop-up books, I realized that attaching a real envelope to a page would be child's play by comparison.

Excitedly mulling over all these ideas, it seemed to me that I had enough information to start building a dummy. In fact, all I needed were a couple of likely characters to start up their extraordinary correspondence.

THE PARTING OF THE RED SOCKS

Once completed, I put the *Griffin & Sabine* dummy aside. I'd used a gestalt technique in developing the two characters, but the enterprise felt a bit too close to home. (Gestalt therapy encourages a person to identify the various conflicting aspects of their personality. Given that Griffin and Sabine were part of my own nature, I mentally isolated them, then encouraged them to speak to one another. It's fascinating how quickly the two characters within oneself polarize, then find a middle ground where neither feels ignored.) However, a few months down the road, I'd become less embarrassed with the thing; and as I was going to England to visit some of the publishers I'd previously done covers for, I took the dummy along in case I summoned up the courage to show it around.

My third port of call was an eminent publishing house, situated in Bedford Square in central London. I'd gone to pick up some old artwork, and while I was there I nervously asked the art director if an editor would take a look at *Griffin & Sabine*. He kindly sent it upstairs and said that if I popped back later in the day it would be returned to me with a response. I did my other chores, came back to the publishers mid-afternoon and spoke, by internal phone, to the editor in question. In the classic tones of the well-bred he informed me, "The idea is moderately amusing, the illustration's fairly competent, but the writing is far from adequate. I'm afraid it's not something we'd care to be associated with." Before I could thank him for his lofty pronouncement, we were disconnected. A minute later a wizened secretary emerged from the bowels of the building and silently returned the dummy to me. I departed, my tail firmly between my legs. For reasons you will see later, I hadn't expected the writing to be taken seriously, and the self-confidence I'd built around my art afforded plenty of protection in that direction, but getting the whole concept of the book so squarely trodden on was truly painful.

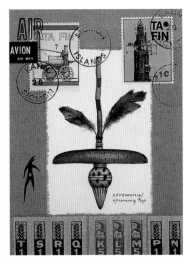

Sicmon Islands ceremonial spinning wheel. I later expanded on the theme of imaginary spinning tops in *The Museum at Purgatory*.

I was English by birth, and I'd experienced that kind of upper-crust put-down on numerous occasions, but never when it was aimed at something so close to my heart.

I almost gave up showing the dummy to anyone again. Certainly, never was I going to expose it to another snotty publisher. Little did I know that my red socks were about to part.

Back in Vancouver I arranged to visit Chronicle, the San Francisco publisher, to propose some book ideas. My oldest and most trusted friend Pat also lived in Frisco, and as we'd agreed to get together, I put the *Griffin & Sabine* dummy in my bag just to show her.

Victoria Rock, who's head of children's books at Chronicle, is a friendly woman, and we chatted easily while I ran through my sketches for a zodiac pop-up book and the series of cards that would eventually become *The Missing Nose Flute*. At the end of the meeting while I was replacing bits and pieces back into my flightbag, Victoria suddenly stopped me and pointed, "What's that?" I looked down and saw that the red socks I had in the bottom of my bag had parted, revealing the *Griffin & Sabine* dummy. After the Bedford Square debacle I had no intention of re-exposing it to the literary world, but Victoria was quite insistent. She'd caught a glimpse of the dark angel on the cover and wanted to see more. I argued with myself. What was the worst thing that could happen? For starters, I could get humiliated again. Conversely, I could receive some kind of encouragement. I took the plunge, leaned down, and passed her the thin volume. She turned the ten pages slowly, opening the two envelopes and reading the enclosed letters. Then she closed the dummy, drew it to her, and said, "I want it." I couldn't grasp what she meant. And then she explained, "I think this will work. Let me show Annie Barrows, one of our adult editors."

I left the dummy with them, not really believing it would become a book. After all, they'd have to find a writer, and it was a pretty risky item even for an innovative publisher like Chronicle.

A month later I was offered a contract. I was amazed. But that was peanuts compared to my surprise when Annie told me that they wanted *me* to write the thing. I thought they were kidding. Sure, I'd written the text for the dummy, but that was really just a fill-in. I was an artist. I couldn't write. Back when I was fourteen, my English teacher, Mr. Ripley, who was a man not overly interested in content, got many a laugh by telling the class that I was a spelling and grammatical disaster area. Maybe he wished to cajole me into greater effort, I don't know; but all he succeeded in doing was stifling any inclination I may have had to write.

But there I was, twenty-seven years later, being informed by an editor that she thought me more than capable of writing a book. Whom was I to believe: Annie Barrows or Mr. Semi Bloody Colon Ripley? It took Annie about a week to convince me. She sent a bouncy letter talking about "this and that" and the plot. In the middle of one of her comments she wrote, ". . . maybe, I dunno." It was that word *dunno* that did it. If a real-life editor could write like that, then surely I could write any way I wanted.

The Samarian Bear. Like Griffin, incarceration has left the bear locked in on himself. I made a version of this creature out of clay, but I didn't hollow it out enough and it exploded in the kiln—wiping out a whole set of someone else's pots. I was not popular!

Griffin — I think that
is too grand. This, I
our tenacity. If we
reward of each othe
Since I returned, th
I can't explain it, bu
having a hard time
designs. Probably m

ABINE
THINGS HAVE BECOME
DIFFICULT. I MUSTN'T
AGAIN. THIS WHOLE A
GOTTEN TOO INTENSE. T
SABINE, YOU DON'T E
INVENTED YOU. YOU
THE STAMPS, THE ISLA
A FIGMENT OF MY IMA
WAS LONELY AND I V
FRIEND. BUT I'M ALM

TOP: Sabine's handwriting is fluid and
relaxed, showing her physical comfort within
herself.

BOTTOM: Griffin's writing is upright and
spiky, befitting his rigidity and uptightness.

READING ALOUD

Talking to even a small gathering of people made me highly nervous, and the idea of public performance seemed so overwhelming as to be unimaginable. Hence, when Alma Lee, who runs the Writers' Festival in Vancouver, phoned to say that they wanted me to step in at the last moment do a reading, the sensible thing would have been outright refusal. But I was not in sensible mode. *Griffin & Sabine* had just hit the bestseller list, and I was walking on air. I was saying yes to most everything, and as the Festival was in a tight spot, why shouldn't I be more outgoing?

As soon as I placed the phone back in the cradle I realized the error of my ways. I put my arms over my head and began to rock back and forth, "You imbecile! What *have* you done now?" But I couldn't back out. You see, I'd been a social wimp all my childhood, and when I reached forty, I'd promised myself I was going to try and grow out of it. I had to go through with the reading regardless.

When I arrived at the theater, I found out that the person I was replacing was none other than Michael Ondaatje. Worse still, there'd been no time to warn the crowd that an upstart was standing in for one of Canada's best writers. I was going to die. No, worse. I was going to get up there in front of five hundred people, I was going to open my mouth, nothing was going to come out, and then I was going to wet myself. This I knew with certainty.

There were two of us sharing the stage that evening. Katherine Govier, who was experienced and had a very easy manner, was opening. She read smoothly and carried herself with all the comfortable demeanor of a pro. While Katherine talked, I squirmed and counted down the minutes to my humiliation.

The break between performances was about ten years too short. My reckoning was at hand. I climbed the half-dozen stairs to the stage in utter dread, eyes locked on the podium like Sidney Carlton hauling himself to his appointment with Madame Guillotine.

I stared hopelessly at the phalanx of strangers. Looking down at my notes, which were far too small to focus on, all I could see was the card someone had pinned to my chest when I arrived. It said, "Nick Bantock, Writer." I looked up, my knees oscillating. And then from somewhere far down inside, a distinctive if slightly shaky voice that I'd never heard before said, "They gave me this badge. It says I'm a writer. So I suppose I must be." And then a wonderful thing happened: The audience laughed. It was such a warm, encouraging sound, that I just babbled on about anything and everything I could think of to do with my work, and amazingly the sea of ears listened attentively.

When it came to the reading, Katherine kindly took the role of Sabine while I read Griffin. Behind us slides of paintings from the book were projected onto a screen. I had been convinced that I would give a repeat performance of the last time I'd read aloud to a group—a

schoolboy stuttering and spluttering through three sentences before being sarcastically told to sit down and make way for someone who didn't have pebbles in their mouth. But I needn't have worried. That night I read without fault for twenty minutes. I didn't know where the confidence had come from, but never was I more thankful for a self-discovery.

I learned a great deal during that performance. I learned to see an audience as a one-on-one meeting and how to take applause. I learned not to focus on anyone who looks miserable. And, best of all, I discovered that I was one of those people who feels comfortable flying by the seat of his pants.

. . . SILENT READING

On the second night of the San Francisco leg of my first tour, the heavy cold that had been threatening to engulf me got a stranglehold on my throat. By the morning I had a voice of mouse-ish magnitude. The day's opening engagement was a radio interview, and I squeaked out my responses into a mike turned up to full volume. Then I allowed myself to be led off to a doctor. The M.D.'s diagnosis was perceptive. I had a sore throat. His prescription was equally to the point. Don't talk.

Only my signing hand was required for the day, but the evening was another matter, as I had been booked to give a reading on the other side of the Bay. My publicist and good buddy, Mary Anne Gilderboom, phoned ahead to the bookstore and warned them, "He has laryngitis and can put in a token appearance, but can't talk." I overheard what I took to be sounds of sympathetic understanding coming from the other end of the line, and I breathed a sigh of relief.

A few hours later, we arrived at the bookstore to find the place stuffed to the gills with over two hundred people, expectantly waiting for me to deliver. Again, Mary Anne explained to the store manager that my voice was virtually extinct and that the best I could do would be to croak a couple of words in apology. But the manager had clearly decided that the better part of valor was to duck, and pleasantly informed the throng that, "Mr. Bantock has a bit of a cold, so please be easy on him."

I groaned inwardly as I moved toward the head of the room, my brains wracking themselves for an escape. I could grate out maybe one sentence before my voice disintegrated. This time there would be no hidden, inner warrior riding to my rescue. My goose was indubitably cooked.

I looked at the audience, all smiles and ready to be entertained. I considered making a run for it. Maybe I could get through the door before anyone caught me. But I knew it was too late for that. What would I say? Then, in the last millisecond, I had an idea. I rasped, "Who'd like to read one of Griffin & Sabine's postcards?"

The room became very quiet. The audience looked at me, then at each other. A chair scraped

Mr. Griffin Moss
s you didn't reply to
ust assume you are re
n my investigations. It i
o so.
Miss Strohem's parents c
uspicions that you and
ully formed one-way
elepathy. Do you realiz

Dear Matthew
It's good to get in touc
with you at last.
We are very impressed
your general diagnost
However we are not co
you should be consider
prescribing penicillin

TOP: I wanted Folatti's writing to imply a mean secretiveness, so I made his hand tiny and ungenerous.

BOTTOM: At the very end of the book Griffin and Sabine's writing becomes more alike, eventually merging into one hand. This proved tricky, as it required joining the inks as well as the letter forms.

and someone started to move to the aisle. I was sure that the slim, fair-haired woman was leaving in disgust. But she wasn't. Instead, she came up to the front and, grinning nervously, said, "I always wanted a chance to be Sabine." And with that she began to read one of the cards. She finished with a beaming smile and was replaced by another from the ranks, and then another, each reader giving their all, some smooth and confident, some scared and stuttery, but every one heroically doing their best and receiving a rapturous ovation from their fellows. For forty-five minutes they enthralled one another. And when they were finally spent, I stepped back in front of the crowd and received resounding applause for doing absolutely nothing. I bowed graciously, strode back down the aisle, and slipped out into the night.

It had been, without doubt, the best reading I'd ever given.

THE EXPLOSION

I knew as soon as I began work on *Griffin & Sabine* that the story I wanted to relate couldn't be told in a single book, and that it would probably take a trilogy to complete the cycle. I imagined I'd have many years to work on parts two and three. I hoped that if I was lucky, the ten thousand copies destined to make up the first print run would quietly sell out, a small cult following might develop, and eventually Chronicle would sanction *Sabine's Notebook*. I thought I was being ambitious!

Chronicle had taken the first proofs to the American Book Association convention, which was being held that year in Washington, D.C. Tens of thousands of new books arrive annually at the show, some backed by acres of hype and big dollars, but most silently as church mice. *Griffin & Sabine* was of the small rodent variety, a quirky book by an unknown, produced by a small West Coast publisher. Yet somehow the word got around and people started talking about the "strange thingy" (as the *Globe and Mail* later called it). By the end of the show, it was selected by the *Washington Post*, along with General Schwarzkopf's memoirs of the Gulf War and the follow-up to *Gone with the Wind,* as one of the six books to watch out for.

Back in San Francisco, Jack Jensen, head of Chronicle, made the brave (some said foolhardy) decision to up the print run to thirty-five thousand. In September of that year, the books slipped into the stores and almost immediately took off. The independent booksellers started shifting them like hotcakes. More were ordered from the printers, but no one could keep up with the demand. Two weeks before Christmas, the stores totally ran out of copies. *G & S* rapidly climbed the bestseller list, and the printer had to go to double shifts. Newspapers all over the country picked up on the book. *Newsweek* and the other magazines wanted to do interviews, a hasty tour was arranged, and I was repeatedly shoved in front of national TV cameras. Everything around me was spinning, and fan letters (which in those early days I determinedly responded to in full) were pouring in by the bucket load.

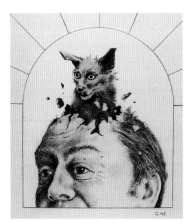

The creature bursting from the egghead is an aye aye. This particular stuffed, ratty specimen was an old acquaintance I visited regularly at the Bristol museum in England.

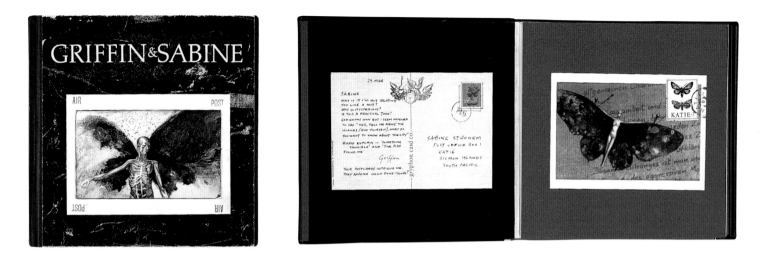

Meanwhile Chronicle was calling for me to finish part two of the trilogy while I was anxiously trying to complete my obligation to create the *Solomon Grundy* pop-up book. Somehow I managed to keep up. But the price was exhaustion. I was getting spread far too thinly, and I dragged myself around pretty much on adrenaline alone. Maybe I should have pulled back, but it was hard. It seemed so all-or-nothing, and I knew that it was my one and only opening to provide for my family's future.

Over the next two years the pattern repeated, as *Sabine's Notebook* and then *The Golden Mean* seemed to capture the public's attention. I started to believe the fan mail and my own publicity, and my ego inflated. I fought against it, but from time to time, when someone was being less than helpful, a small voice in my brain would say, "Do you know who I am?" I never actually spoke the words, but I felt the arrogance, and the gap between whom I pretended to be and the reality of my deep-rooted sense of inconsequentiality turned into a chasm. I was frightened that my inbred sense of failure was transparent, so I went into denial. And all the time the books kept selling—three million worldwide.

Eventually my bubble of self-opinion burst and I came down to earth with a heavy clonk. If I'd been more grounded in the beginning, I might have handled the demands better. But the truth was, I was out of my depth. I knew nothing about being a best-selling author. For example, when *People* magazine asked to do an article on me, I didn't even know who they were! I had been an artist who didn't think he could write who suddenly found himself on the end of other people's dreams, ambitions, and resentments. That's not to denigrate success itself. It's wonderful to have so many doors opened that would have remained tightly closed if it hadn't been for the trilogy, but the wear and tear of being a projection (other people's and your own) is tough.

It's been over five years since those insane days, and my life has gone through many

The original dummy, made shortly after the idea for the book struck me. In size and layout it's remarkably similar to the finished book. I find it interesting that the concept should have surfaced in such a complete form.

changes. I've continued to work and have had more best-sellers, but I thank the heavens that it is highly unlikely that I'll ever again be dragged along the tracks by such a runaway phenomenon.

THE WIDENING GYRE

Griffin & Sabine is a journey, a search, a fairy tale, a psychological mystery, and a love story. It has many themes and mythic traditions woven into the body of text and image, most of which are related to the struggle between externalized desire and an internal pursuit of balance. Griffin hankers for that balance, but he has a problem: How can he belong to the whole, if *he himself is divided?*

The search to find a perfect partner mirrors the progress made within oneself to bring together the opposite aspects of one's nature (male/female, conscious/subconscious, light side/dark side etc.). Griffin's need to construct Sabine within himself is echoed by the reality of Sabine's appearance in his life. So the answer to the question "Is Sabine real or a figment of Griffin's imagination?" is yes! Yes, she exists because he needs her to. This also applies the other way round. He is only real because she has constructed him. It's hard to wrap one's mind around this kind of thinking because we've been taught that we have to choose between black or white, good or bad, you or me. But denying selected parts of ourselves that we don't like can never work. We will always be frustrated, because balance is a constant process of accepting ambivalence. Griffin has to come to terms with that, or go crazy.

Each part of the trilogy begins and ends with a section of W. B. Yeats's "The Second Coming," and in many ways the poem acts as an anchor to the story. Reference to Armageddon and political upheaval aside, I tend to see the verse as both a message of hope and a warning. The great sphinx that rises from the desert sands may well bring with it the end of the world, but equally it might represent a new beginning. Thus the gryphon (or dark angel) that we see arise and emerge from Griffin Moss may either destroy or transform him.

On the first occasion I read "The Second Coming" it stopped me dead and set a drum pounding in my head that scared and excited me beyond reasonable understanding. If ever there was an anthem to our age, this for me would be it.

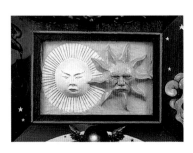

Griffin & Sabine's alchemical theme of Brother Sun, Sister Moon, was not new to me. I'd used it long before in this relief sculpture. The winged ball on the lower half of the frame would later be surmounted with a gryphon. (1975)

> Turning and turning in the widening gyre
> The falcon cannot hear the falconer;
> Things fall apart; the centre cannot hold;
> Mere anarchy is loosed upon the world,
> The blood-dimmed tide is loosed, and everywhere
> The ceremony of innocence is drowned;
> The best lack all conviction, while the worst
> Are full of passionate intensity.

Surely some revelation is at hand;
Surely the Second Coming is at hand;
The Second Coming! Hardly are those words out
When a vast image out of *Spiritus Mundi*
Troubles my sight: somewhere in sands of the desert
A shape with lion body and the head of a man,
A gaze blank and pitiless as the sun,
Is moving its slow thighs, while all about it
Reel shadows of indignant desert birds.
The darkness drops again; but now I know
That twenty centuries of stony sleep
Were vexed to nightmare by a rocking cradle,
And what rough beast, its hour come round at last,
Slouches towards Bethlehem to be born?

 —W. B. Yeats (1921)

MEAN ENDING

As for the closure of *The Golden Mean*, I have been asked often to explain it, and to date I have always refused. However, if I were to do so, this would probably be the best time and place.

But of course I'm not going to. Tying things up with a ribbon would be meaningless, especially as I believe that it's best if each individual comes to terms with his or her own interpretation of the elliptical aspect of the ending. The poem should help, as should the handwriting toward the last pages of the book. Also the name and stamp that appear on the last card. The serpent devours its tail, and Dr. Matthew Sedon could be any of us. The closing you choose simply defines where you are standing.

One last piece of help—a definition of the title: There is a place on any given line where the ratio of the smaller part to the larger is the same as the larger part to the whole line. The ancient Greeks called this place of division *aurio sectio* or The Golden Mean. It is the harmonious point of balance that sits at the heart of aesthetic beauty. It has governed the composition of art and architecture from the Parthenon to Cézanne, and as a mathematical formula it can be used to describe both sea shells and spiral galaxies.

The Golden Mean needs neither calculator nor dividers to define its placement, for within each of us lies the ability to pinpoint its position precisely.

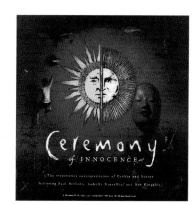

Ceremony of Innocence. Numerous CD-ROM companies offered to create a version of *Griffin & Sabine*, but I chose Peter Gabriel's organization, Real World, because I believed it was most prepared to stay within the spirit of the story. And so it proved to be. Alex Mayhew's art direction, Gerrie Villon's production, and the rest of the team's sweat and tears eventually created an "electronic theatre of the imagination," that won awards throughout the world. Working on the project led to many unexpected experiences, such as the time I found myself sitting in a snowbound recording studio in New York, while Isabella Rosellini read the part of Sabine. At one point we asked her to hum something, and for a second I could have sworn that I was sitting in Rick's café listening to her mom do "As Time Goes By."

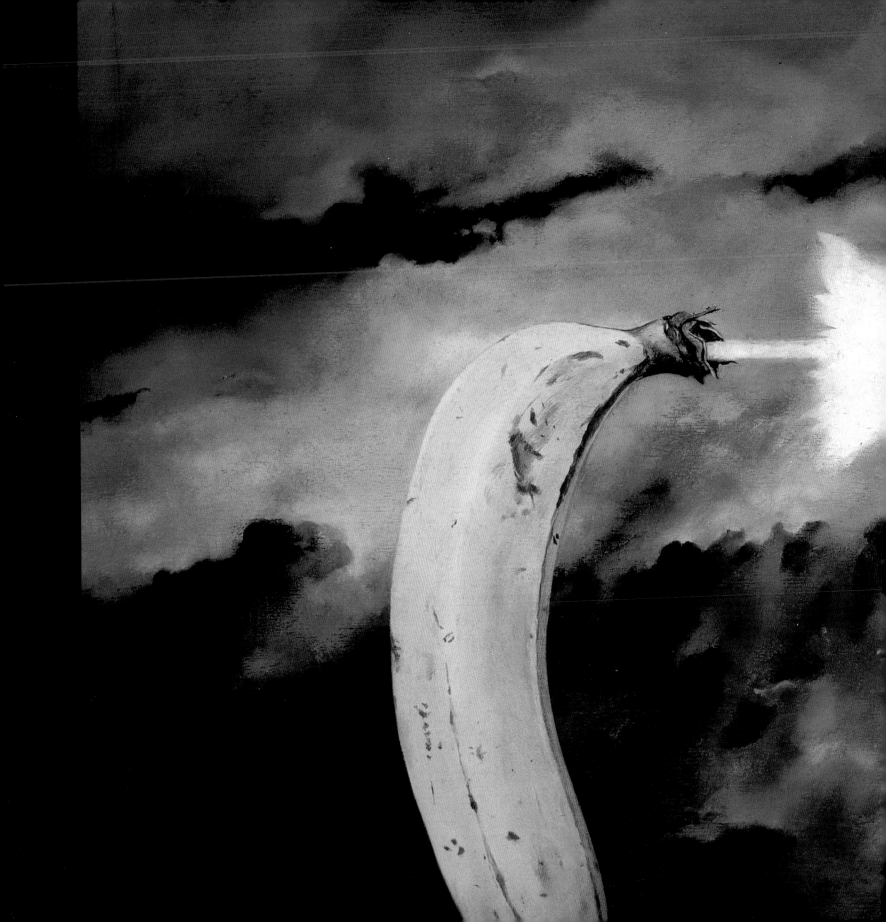

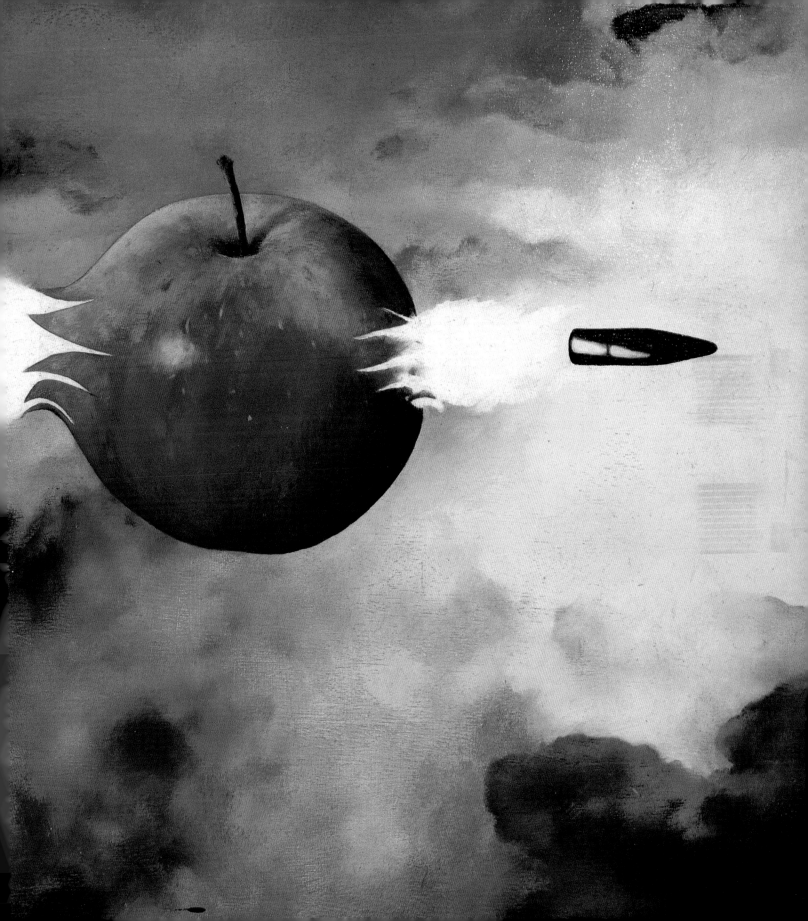

PREVIOUS SPREAD:

"Frankie and Johnny were lovers . . . " In this version, it's Frankie who's the banana, thus reversing the regular phallic symbolism. This dramatically absurd scene should be viewed while listening to Wagner's *Ride of the Valkyries.*

BELOW: Sabine's art, at least in the first book, has a playful quality. I got the idea for the petroglyphs from Kim Kasasian. She'd been using them in her drawings for a while, and I asked if she'd mind if I also messed around with them. After a little practice I could create non-specific petros of my own. And it was these little creatures that became Sabine's familiars.

FACING PAGE, LEFT: Leda without the swan. A different form of self-exposure.

FACING PAGE, RIGHT: First drawing of the parrot and his feather.

FACING PAGE, BOTTOM RIGHT: On one of her envelopes, Sabine names and describes the six islands that make up the Sicmon group: "Arbah, the fishing port, where my childhood sweetheart grew up; Katie, home; Katin, seat of the island's council and my workplace; Ta Fin, thick forest (I've been lost there three times); Quepol, the water island; and Typ, which houses the great carved wooden lighthouse."

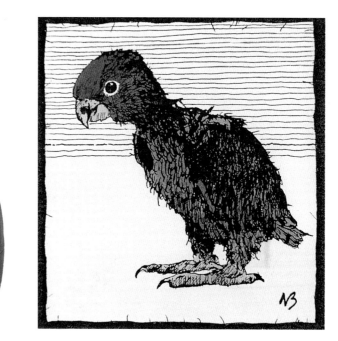

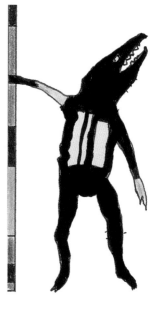

You probably won't have
heard of our islands —
they've no more than specks
of dust in standard
atlases....

AIR7 7

QUEPOL

Griffin Moss
41 Yeats Avenue
London
NW3
England

Arbah
Katie
Katin
Hafmon
Sea
Ta Fin
Quepol
Typ

The Sicmon Islands

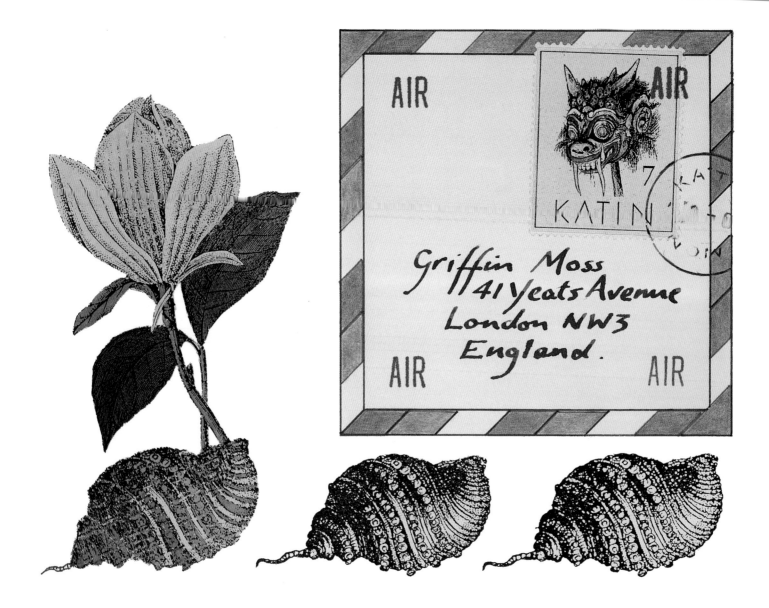

AIR AIR

7

KATIN

Griffin Moss
41 Yeats Avenue
London NW3
England.

AIR AIR

ABOVE: Sabine's shell-lily envelope with a double-fanged, solstice mask stamp. Shell-lilies are found only on the Sicmon Islands. They grow directly out of the shell's heart, and reach heights of up to eight feet.

RIGHT: Flying frog and blue angel envelope. Sabine's address had to be dropped into the white space at a later stage.

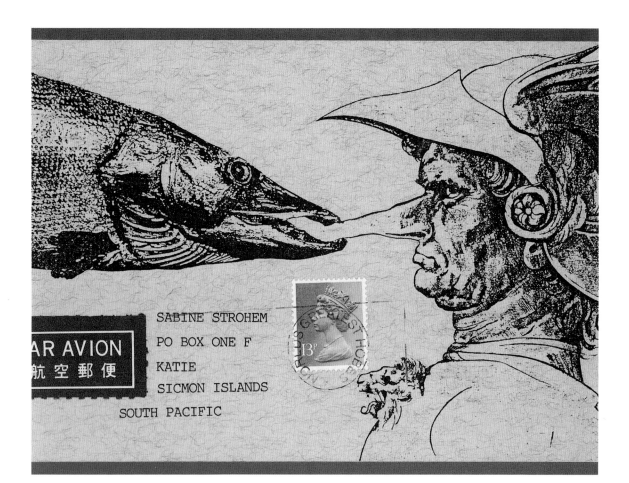

SABINE STROHEM
PO BOX ONE F
KATIE
SICMON ISLANDS
SOUTH PACIFIC

AR AVION
航空郵便

In the first editions of *Griffin & Sabine* the envelopes were mistakenly gummed, and when the books were transported, moisture sealed some of them. I was worried that this might put people off, but it only added to the intrigue.

LEFT: Leonardo's Warrior having his nose stretched by a passing pike.

BELOW, LEFT: Envelope of petroglyphs glowing at night.

BELOW, RIGHT: The falcon from the widening gyre and its hoodwink (the blinding cap used to stop the bird from fleeing the falconer's wrist).

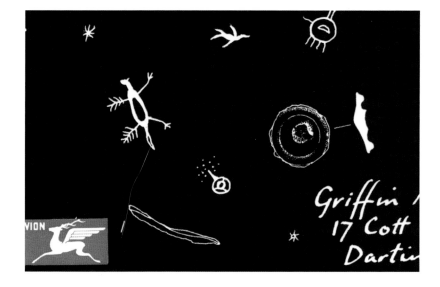

Griffin
17 Cott
Darti

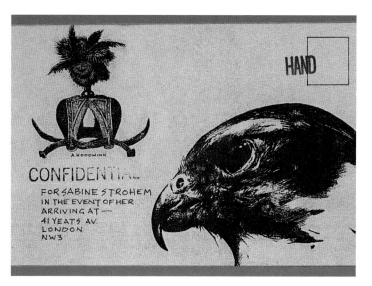

HAND

CONFIDENTIAL
FOR SABINE STROHEM
IN THE EVENT OF HER
ARRIVING AT —
41 YEATS AV.
LONDON
NW3

FACING PAGE: Griffin in Greece, cold and
lonely, and making a mockery of Lord
Byron's image of the heroic Englishman.
THIS PAGE: *Man Descending* . . . was a play
on Marcel Duchamp's painting, *Nude
Descending a Staircase*. The model for the
picture was an old friend, Nick Campion
(the British astrologer). We tied his feet to
the stairhead and lowered him down the
steps—god knows how he kept smiling.

The Blind Leading the Blind was christened after Breughel's painting. These baby king-fishers may be stumbling ugly blobs, but one day they will emerge as exquisitely dressed adult birds.

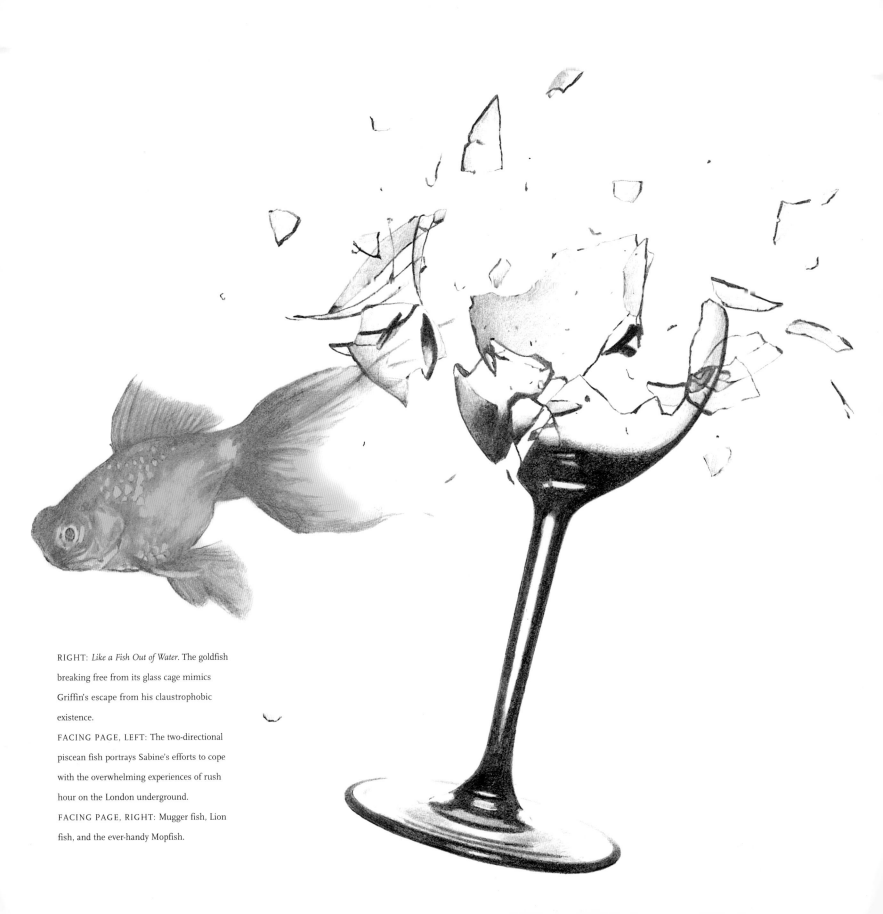

RIGHT: *Like a Fish Out of Water.* The goldfish breaking free from its glass cage mimics Griffin's escape from his claustrophobic existence.

FACING PAGE, LEFT: The two-directional piscean fish portrays Sabine's efforts to cope with the overwhelming experiences of rush hour on the London underground.

FACING PAGE, RIGHT: Mugger fish, Lion fish, and the ever-handy Mopfish.

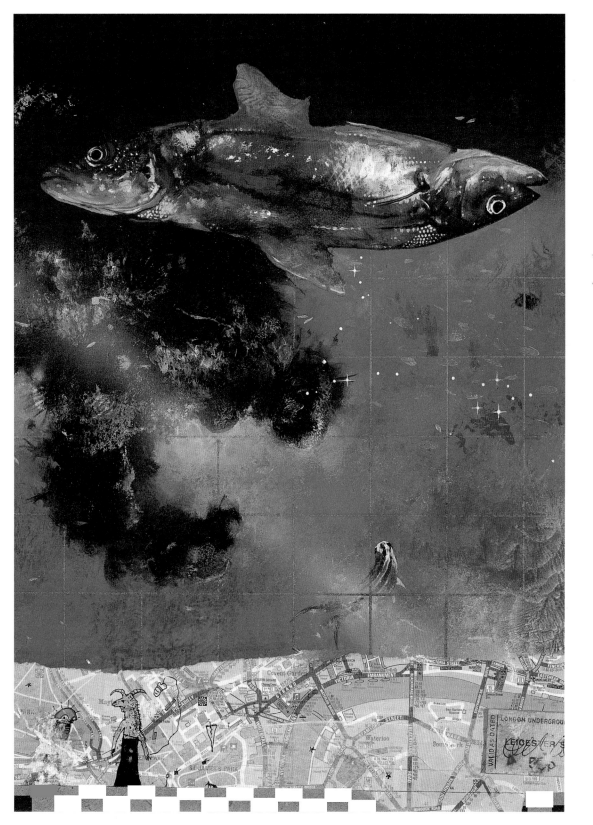

Fool's Mate. Fool's mate is a chess term that refers to a specific quick defeat. However, in this instance, a glance into the night sky will show that it's the queen, not the king, who has fallen—adding to the possibility that Griffin's hold over the situation is slipping.

PAR AVION

The Alchemist. The shadow from the climbing boy casts a demon across the old man's face. In the same vein, Griffin continues to fear Sabine's ultimate intentions.

From *The Kangaroo in the Red Hat* to *Puck*.

The red hat passes from character to character.

Griffin's transformation is a relay race.

It's no accident that Puck is wearing a fez, for

Griffin will meet his muse in Alexandria.

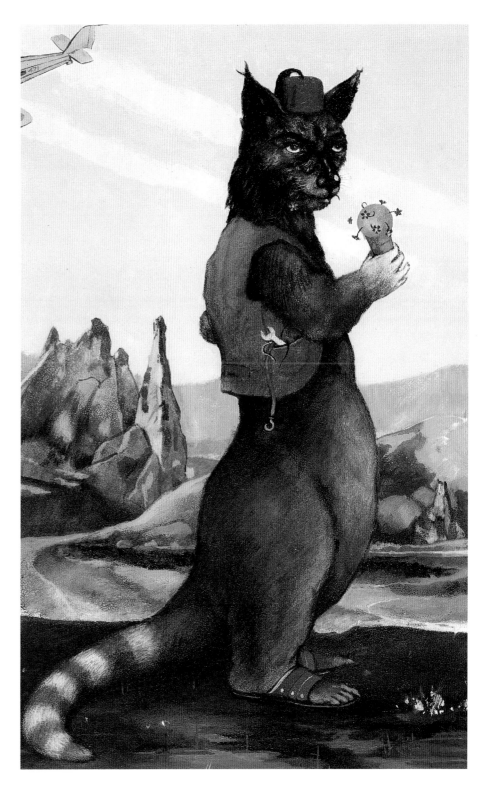

LEFT: When Sabine comes to London she brings her own world. I imagined her familiars (the petros) sweeping across Europe to join her in the English capital.

BOTTOM: Some of the petros are unable to escape the vortex that sucks them down.

FOLLOWING SPREAD: *Duchamp Doubling Up as Cardinal Richelieu.* London has a dark underbelly. When I lived there I developed the sensation that a world existed beneath my feet, a place of ancient plague pits, tunnels, and spectre-haunted sewers.

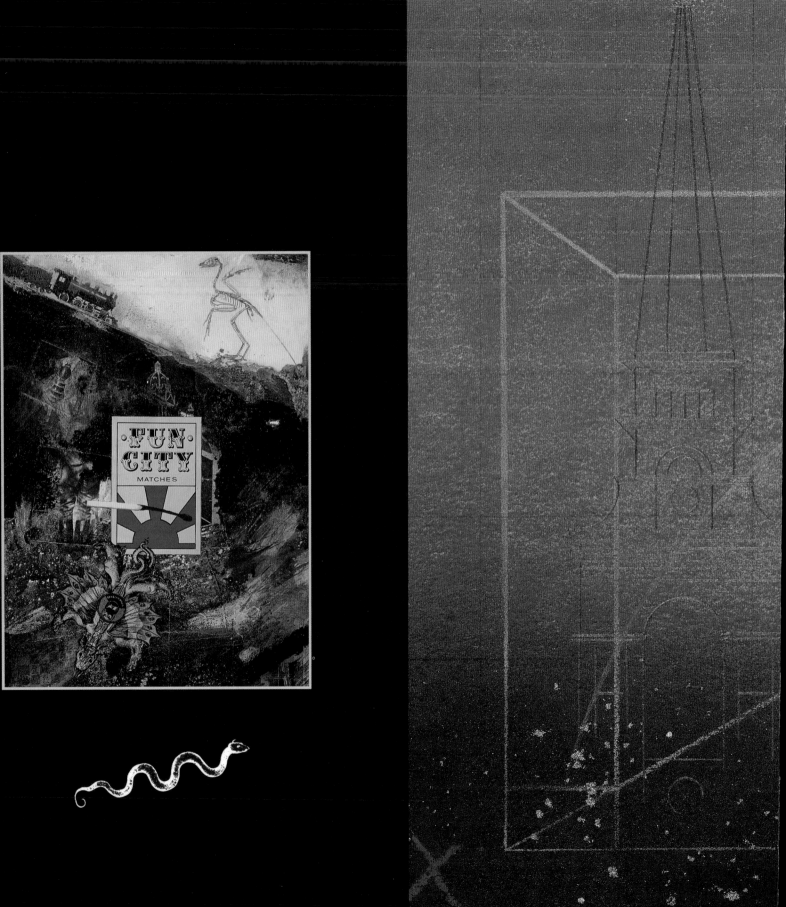

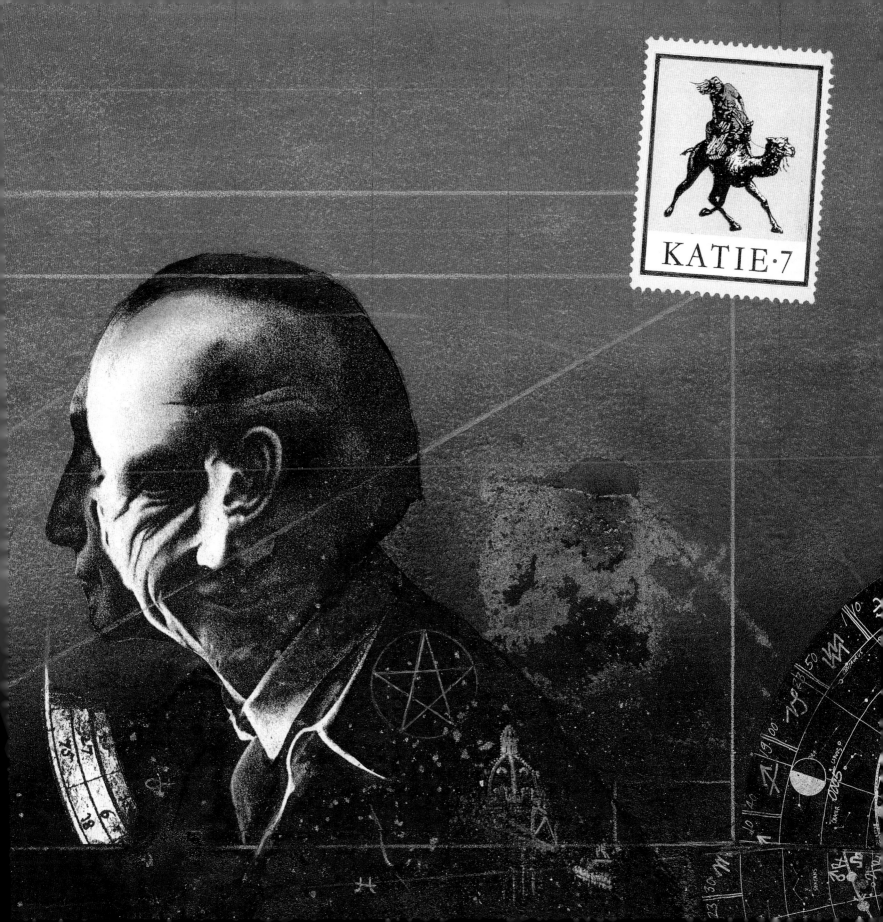

KATIE·7

FACING PAGE: Sabine in Griffin's Florentine
dream.
ABOVE: Sabine's revelry on the great earth
mound known as Maiden's Castle. Sabine's
elusiveness is an essential part of her exis-
tence for Griffin. The intangible and the
unreachable become all the more desirable.

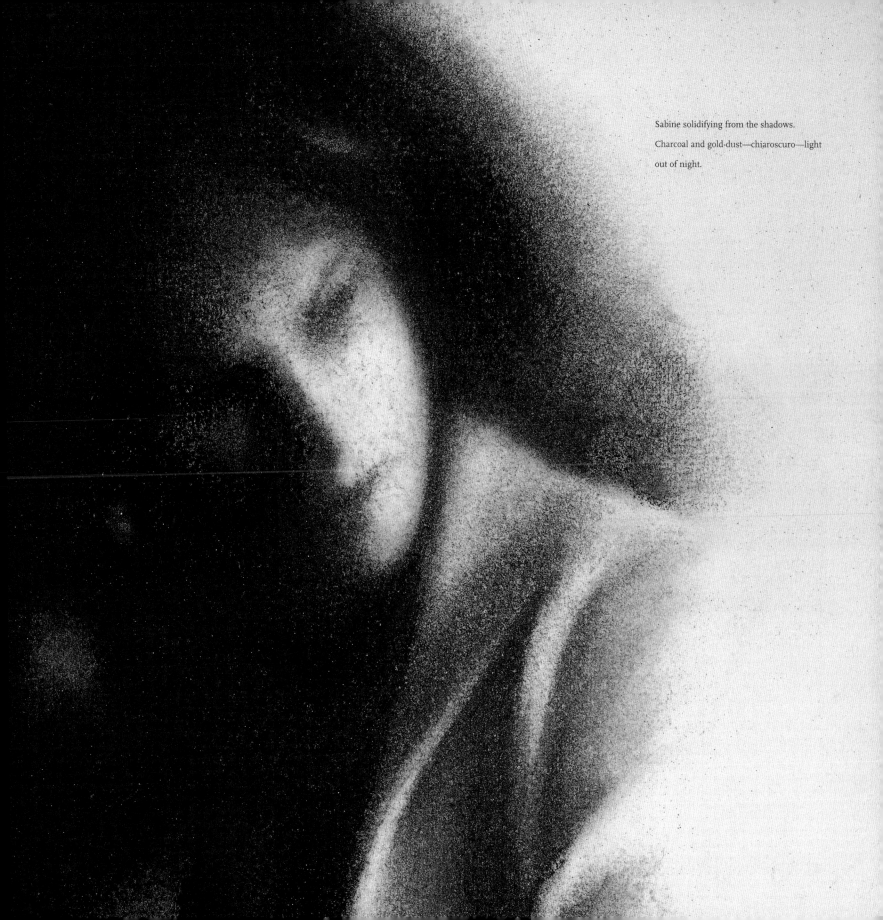

Sabine solidifying from the shadows.
Charcoal and gold-dust—chiaroscuro—light
out of night.

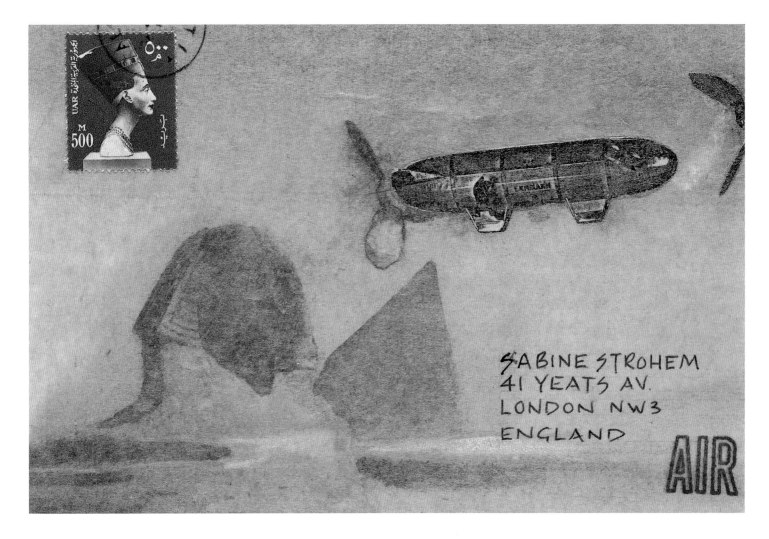

SABINE STROHEM
41 YEATS AV.
LONDON NW3
ENGLAND

AIR

As far as I know, there's no obvious cultural link between Egypt and Japan, yet I feel a resonance between the two that's hard to define. In this series of cards and letters I've tried to show the gradual overlap of imagery as Griffin moves from one ancient society to the next.

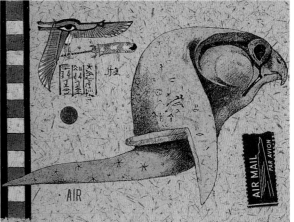

Wings appear repeatedly in the imagery of
Griffin & Sabine. Whether on a monkey, an
angel, or a devil, they signify transition.

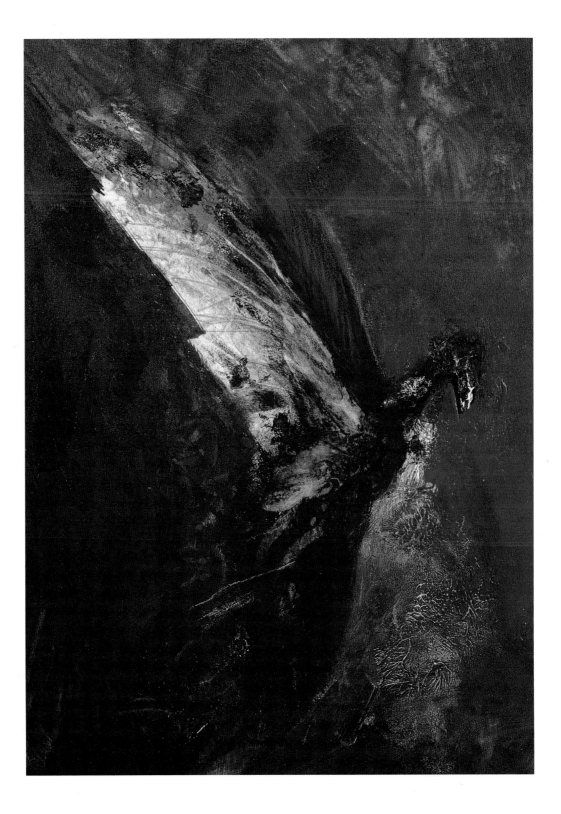

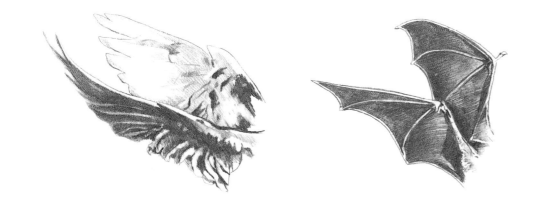

FOLLOWING SPREAD: Sabine's peacock feather card and Griffin's *Pierrot's Last Stand.* Night worlds—alternative universes, felt but not fully seen.

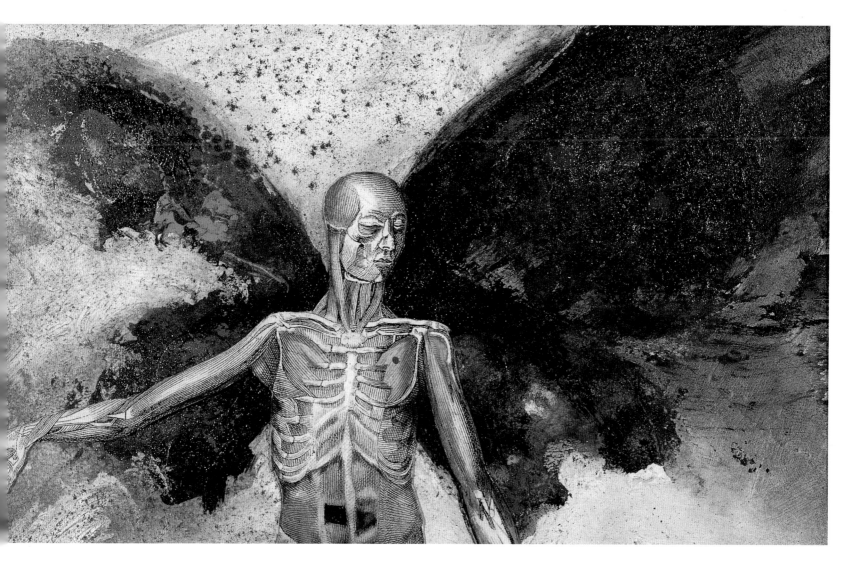

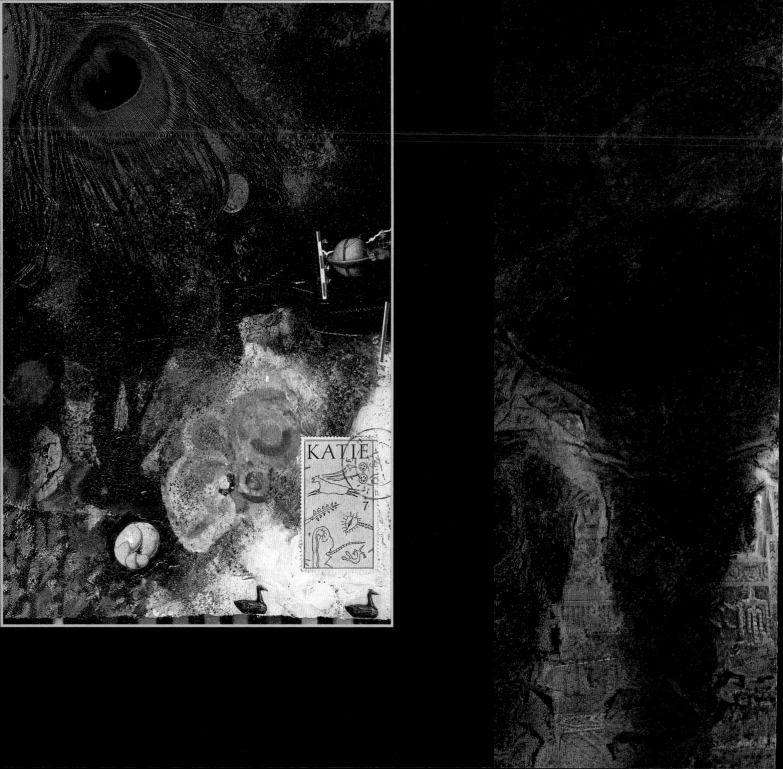

In sequence, the reader/viewer is taken from
Minaloche the cat, to the cat-man stalking
the moon, on to the lion devouring the sun.

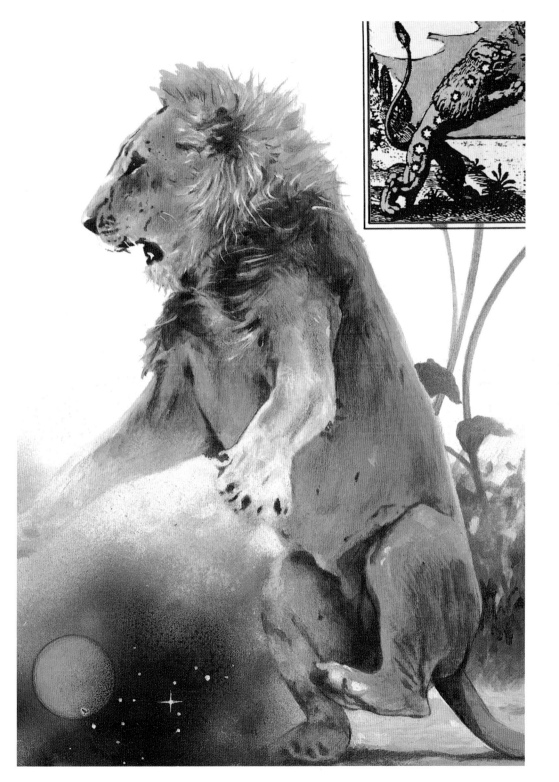

FOLLOWING SPREAD: *The Wheel of Fortune* and *The Second Coming.* I am fascinated by the idea of a great, ancient mechanism driving the universe, grinding out its gold dust and magic.

The Russia Drawer. One of the ten from
The Egyptian Jukebox. The black rectangles
on the sides and top of the box act as a latitu-
dinal and longitudinal grid for navigation.

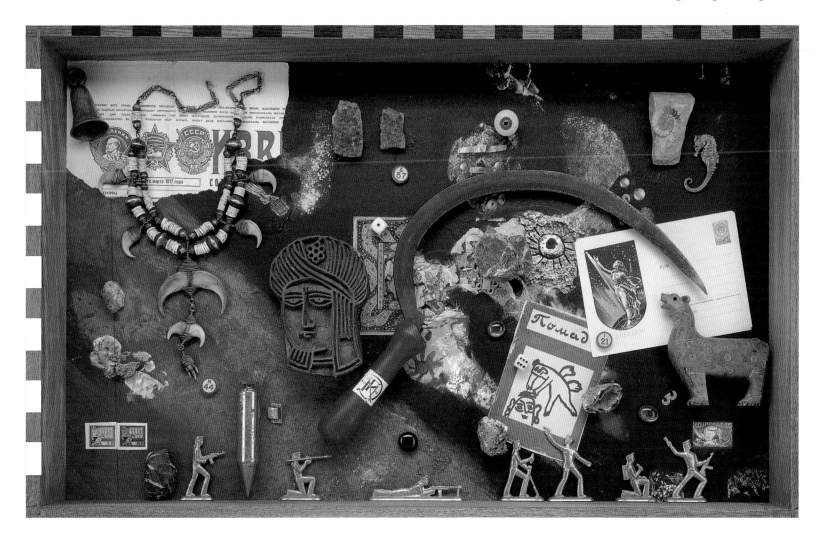

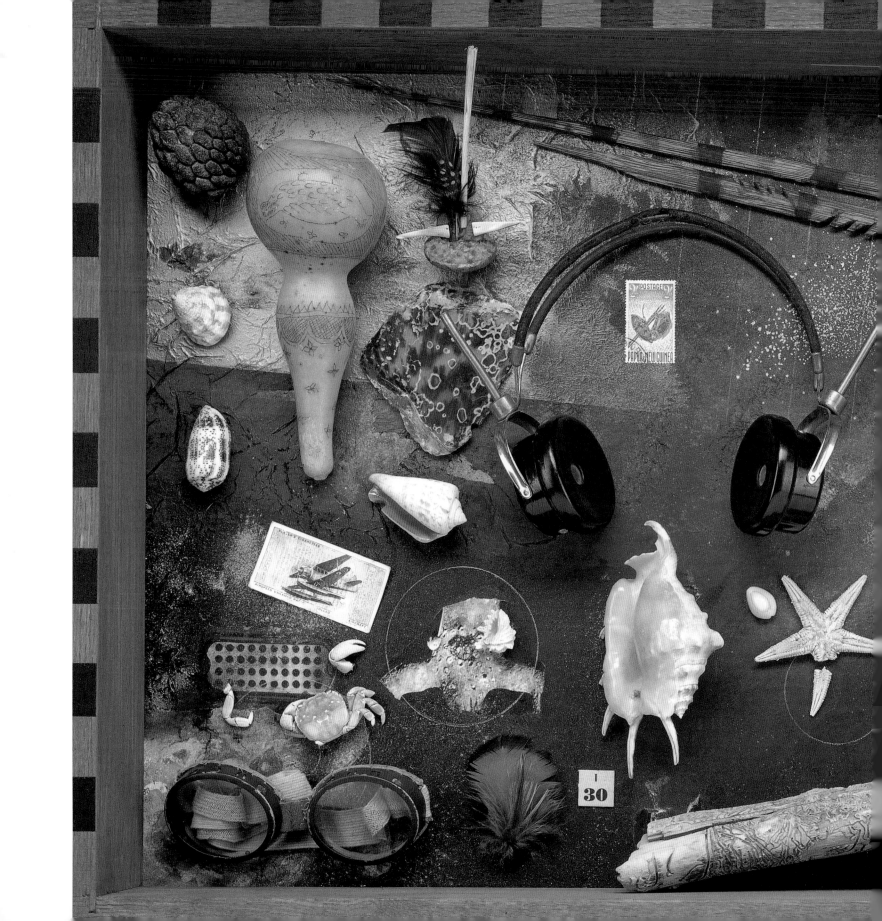

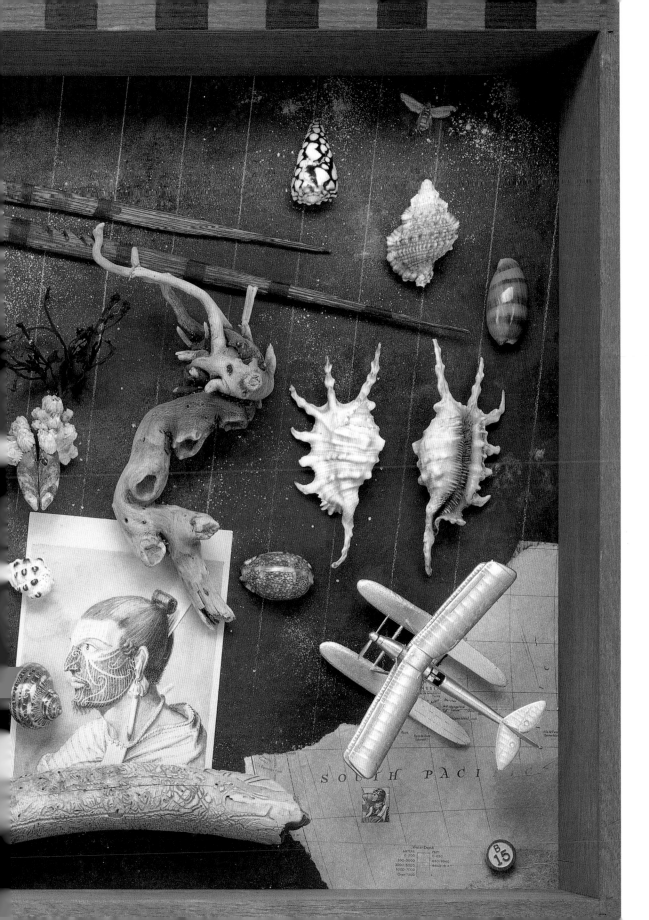

The South Seas Drawer. This drawer tells the story of Hamilton Hasp getting lost while flying solo in his seaplane over the South Seas. He lands on an uncharted island and discovers many unrecorded species of flora and fauna. Unfortunately, when he tries to relocate the island a few weeks later, he cannot find it.

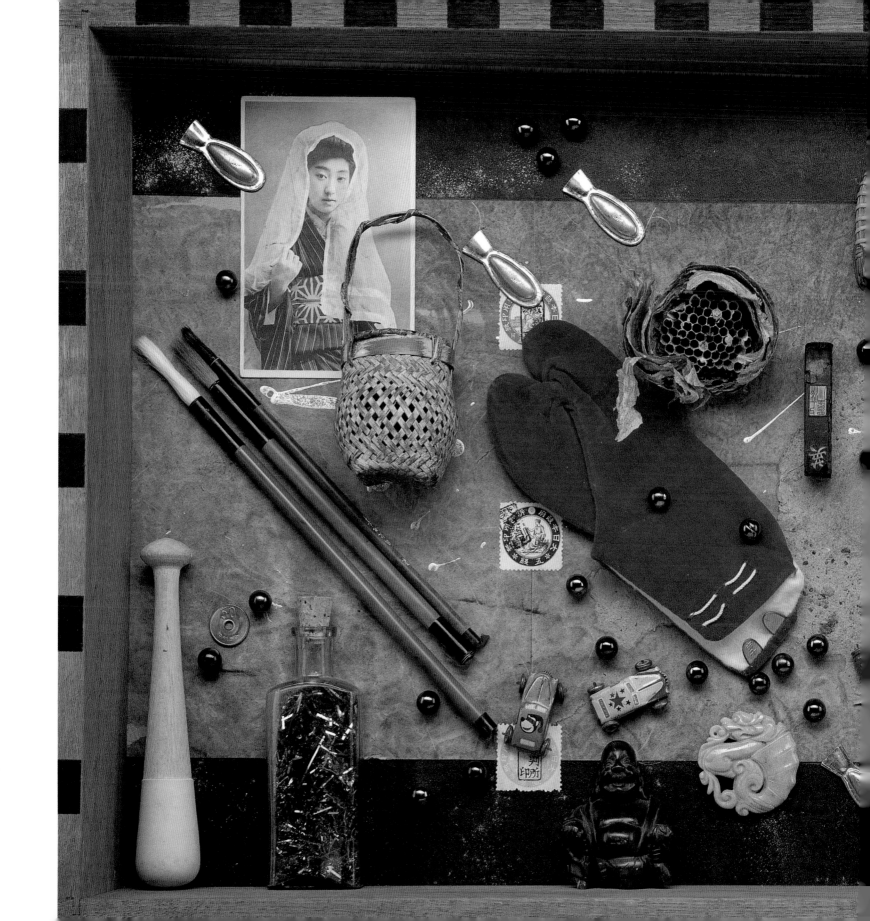

The Japan Drawer. Hasp goes to a small village northwest of Kyoto that is famous for papermaking. There, on the Night of the Spiders, he watches as a great army of spiders dances over specially prepared paper pulp, crisscrossing it with the finest of silver webs.

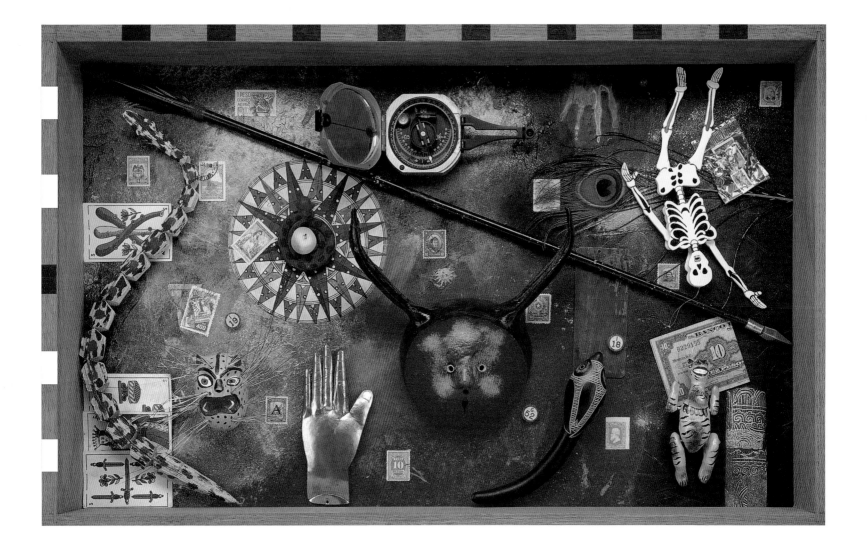

FACING PAGE: *The Colombia Drawer.*
Hasp is sent into a trance by the pungent
smoke from a campfire, is offered an apple
by a giant snake with a devil's head, and is
saved by an unseen bowman.

BELOW; *The Paris Drawer.* On the inner
stairways in Notre Dame cathedral, Hasp
stumbles upon Esmeralda's lost shoe, and
hears the pained cry of the hunchback,
Quasimodo.

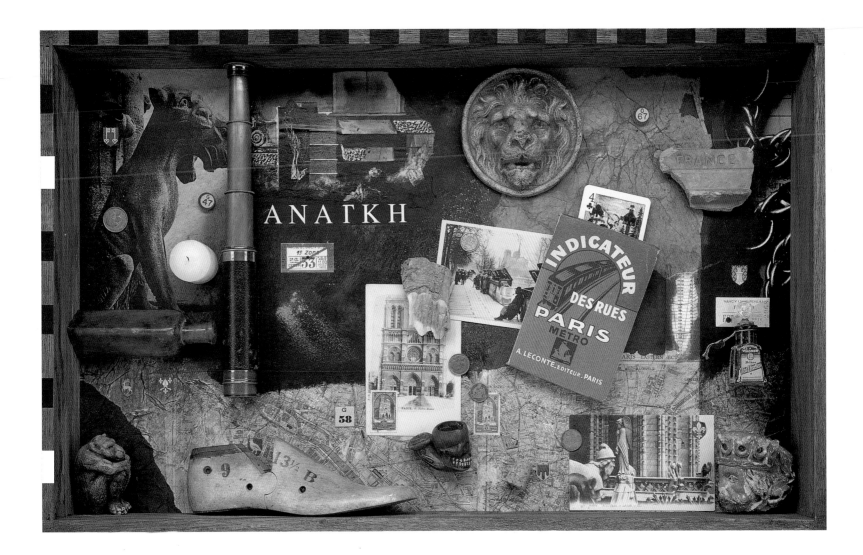

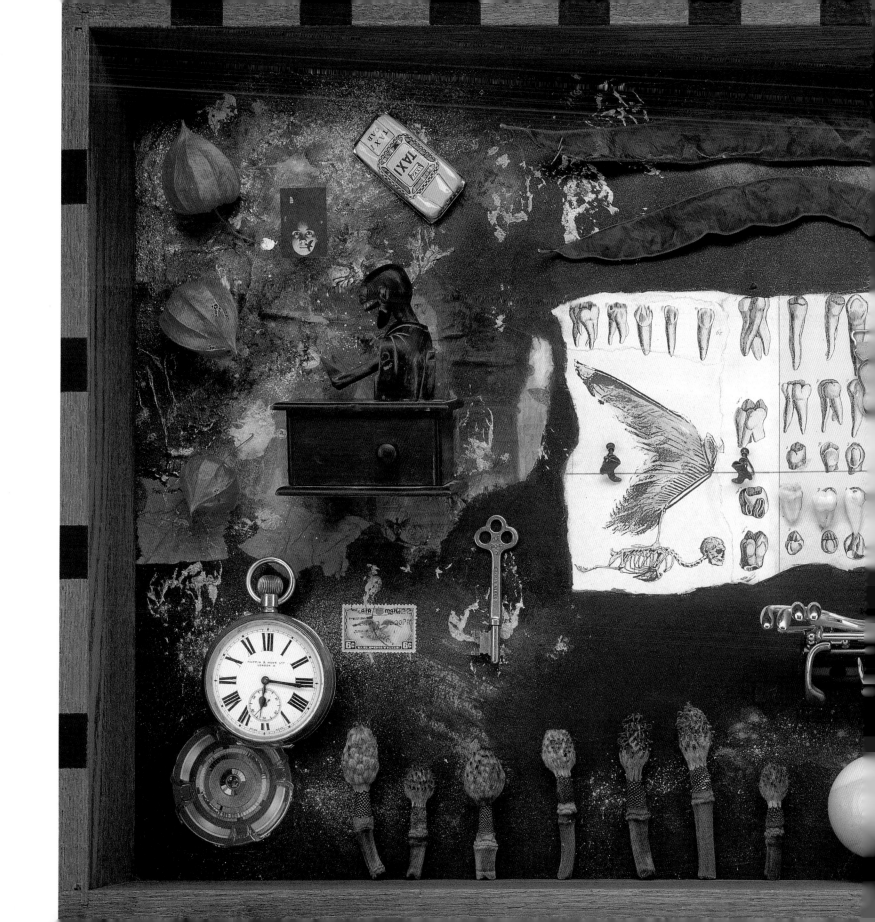

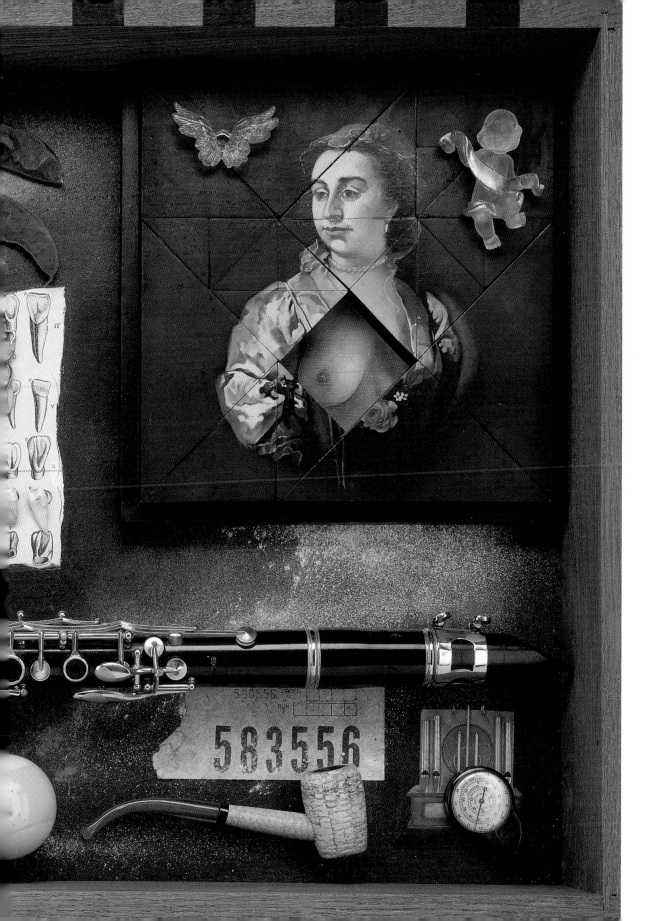

The New Orleans Drawer. Hasp has a brush with an Angel of Death from a bordello. By showing old-fashioned courtesy to a beautiful woman who turns out to be a vampire, the young Hasp avoids the fate that had befallen more than thirty less well mannered souls.

TOP: *The Florence Drawer.* Hasp is told how
Leonardo's master, Verrocchio, achieved
redemption from carving a statue of David.
BOTTOM: *The Egypt Drawer.* In the Valley of
the Kings, a mummy pays a visit to reclaim
an ancient doll from Hasp's parents.

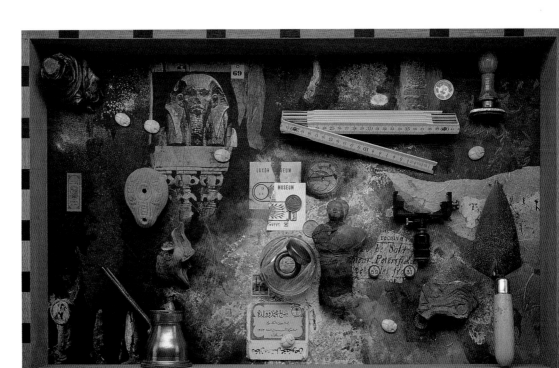

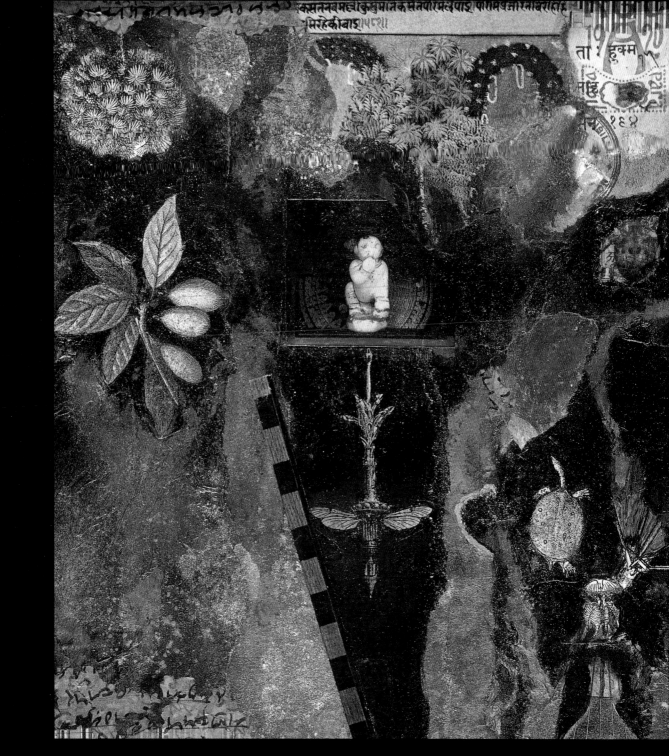

PREVIOUS SPREAD, LEFT:

The Hands of the Buddah.

PREVIOUS SPREAD, RIGHT:

The Spinning Albino.

FACING PAGE: Ganesha oil painting and collage. One day while sitting on an airplane going to England, I was struggling to write about Ganesha. I looked over at the guy next to me, and saw that he was reading the Oxford University Press book about the elephant god. He turned out to be an expert on the subject, and fed me all the information I needed, thus enhancing Ganesha's reputation for helping us ordinary folk.

RIGHT: Sara's elephantine parody of the famous 1918 U.S. airmail stamp error, known as The Inverted Jenny.

CENTER: Sara's pachyderm toothbrush.

BELOW: Map of Niccolo Dei Conti's travels. In constructing the map I attempted to age it (staining, denting, creasing, and banding it) without totally destroying its legibility.

BELOW LEFT: Sara's elephant monoprint on a scrap of handmade paper.

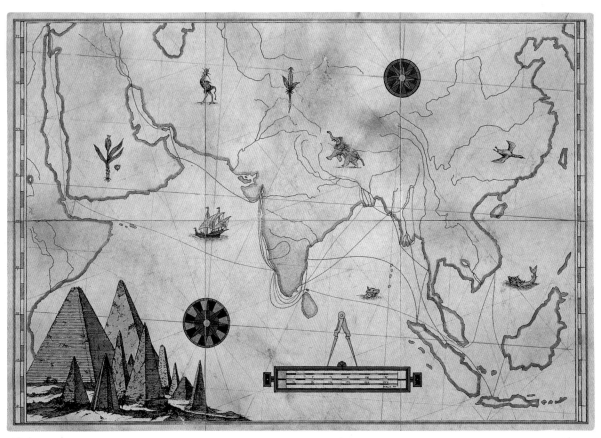

ABOVE: From Sara's diary. She employs a
couple of Eadweard Muybridge figures pacing
opposite ways around a track.

LEFT & FACING PAGE: Two collages
mixing the sensualism of Indian sculpture
with fragments of paper ephemera.

FOLLOWING SPREAD, LEFT: *V.P. 136*.
I have a real affection for luggage labels,
particularly ones with stamps on them.

SAME SPREAD, RIGHT: A child stands on
an early electromagnet, and Edwardian figures
climb a mountain: all part of Sara's symbolic
universe.

縣小縣之縣主也天皇御年玖二眞黒比

アカタヲアカタノ アガタヌシヲキ○コノスヘヒコノ ソヒトドレロ○

日賣命者當時歸神。故天皇坐二祖建忍

PREVIOUS SPREAD, LEFT: *Paradise Found.*

PREVIOUS SPREAD, RIGHT: *Wheel of Fire.*

RIGHT: Graphite drawing of celestial woman.

FAR RIGHT: Graphite drawing of half Shiva, half Parvati.

BOTTOM LEFT: To my knowledge there is no likeness of Niccolo Dei Conti; therefore I was obliged to invent one.

BOTTOM RIGHT: Wash and colored pencil drawing on Egyptian parchment.

The ritual of embrace incarnate in these sculptures is now no longer foreign to me. Congress is not the devil's plaything. Nor is it a sweetmeat to be tasted and thrown away at whim. Mrs Coburn, the guide of my sensual transmigration, has shown me the spiritual freedom that comes on the road to physical bliss. She has opened my eyes and my body to the universe. I will forever be beholden to her for opening my ears to Shiva's drum.

ABOVE: Shiva's hand. Graphite and wash. LEFT & BOTTOM RIGHT: In order to create convincingly aged pages for the Rev. Bacon's notebook, I stripped leaves from an old stamp album, soaked them in coffee, burnt and creased them, then photocopied my original renderings onto the paper before finally penning the text.

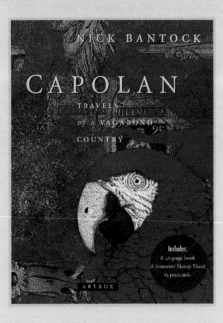

NICK BANTOCK

CAPOLAN

TRAVELS
of a VAGABOND
COUNTRY

Includes:
A 48-page book
A Souvenir Stamp Sheet
15 postcards

ARTBOX

Capolan

INVENTING A NATION

"I have always rather admired the vagabond kingdom and its nomadic people. Any country that can officially exist in fifteen different locations must be respected for its determination and its political creativity."

I invented Capolan because I wanted there to be a good-natured homeless state that cared more for its people than it did for its wealth and geographic patriotism. The country's creation gave me an excuse to make a new set of postcards and stamps (something I'd missed working on since completing the *Griffin & Sabine* trilogy) and an opportunity to touch on a serious subject in a lighthearted way. Books often speak to the already converted, but it struck me that in another format the message might find its way to different eyes. So I conceived *Capolan* as a gift item, a fifth column in a bright box.

Capolan (named after its founder, Mikal Capolan) is a fully fledged community with non-dogmatic religious beliefs, generous political philosophies, and heroes (like Atta Dijjo, who made himself into a human bridge to save his fellows, and was fondly known as Atta Boy). It has traditions, rituals of marriage and death, music, and a language (which relies on pitch changes and conjunctive adnouns). It also has a history: In 1348, fleeing from the devastation of the Black Death, a small group of Germanic villagers met with a band of aesthetes who had recently been cast out of Egypt. The results of that encounter were the olive-skinned children of Capolan. Thirty-one years later, after being chased out of their secluded Hungarian valley by Moravian mercenaries, the Capolanians moved to Thorn and Danzig, then back down the border of the Holy Roman Empire to a new home on the Adriatic. For over one hundred years they remained secure, until the church decreed them *corruptives*, and drove them into the Ottoman domain of Montenegro. The Capolanians lasted a mere two years there before accusations of frog tampering (they were blamed for a rainfall of amphibians in the spring of 1675) had them trailing off to Armenia. In 1698, they began a twenty-year journey that ended by the shores of the China Sea. By 1815, the spiritual rejuvenation they'd undergone seemed to be

ABOVE: Sixteenth-century example of Capolan text. Translation is hampered by the seven half letters that had been added to the base alphabet of thirty two.

FACING PAGE: Box cover for *Capolan*. In retrospect, it looks like the parrot swallowed one too many fermented berries.

RIGHT: The first of fifteen postcards each representing one of the Capolan homelands. The Postmaster General of Capolan asked that the cards capture the magnificent haphazardness of his county's history.

waning, and they unanimously agreed to retrace their steps westward to Southern France and Catalonia. With the conflict of World War I imminent, the Capolanians repaired to a deserted park zoo near Zurich, where they sat out the conflict in relative peace. Upon the cessation of fighting, the Wuttenberg Congress offered Capolan territory near Regunsturg, but they declined, preferring to leave en masse for New Mexico in the United States, where they built harps and bred Brahma chickens. At the end of WWII they returned to Europe and, after years of existential pressure, the Moving Council of Elders agreed to remove Capolan from the world map altogether in 1967.

As a stateless state, Capolan applied for membership to the United Nations in 1999. The Capolanians question the assumption that a nation's existence is determined by territory, and are asking for a ruling that gives a group or individual the right to be recognized in other than economic or military terms. The UN is still debating the issue.

Beliefs: The Capolan ethos is very hard to define. Its roots lie in Zen and Sufi, although it also incorporates a sophisticated system of random absurdity.

When Tabul Harak, the present council spokesperson, was asked to define the Capolan faith, he described it as being "a highly disorganized religion." He went on to say that "the soul of the universe does not require adulation; each individual must define his or her own path away from selfishness and malice. As a society we tend to find dogma unhealthy."

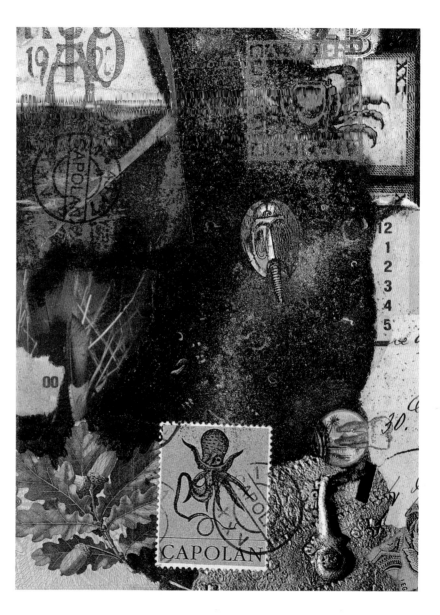

LEFT: Capolan carnet de timbre.

Collective: Capolan is a society that does not encourage or stimulate competitive acquisition. If a Capolanian acquires any excess, he or she automatically passes it on to those who require it.

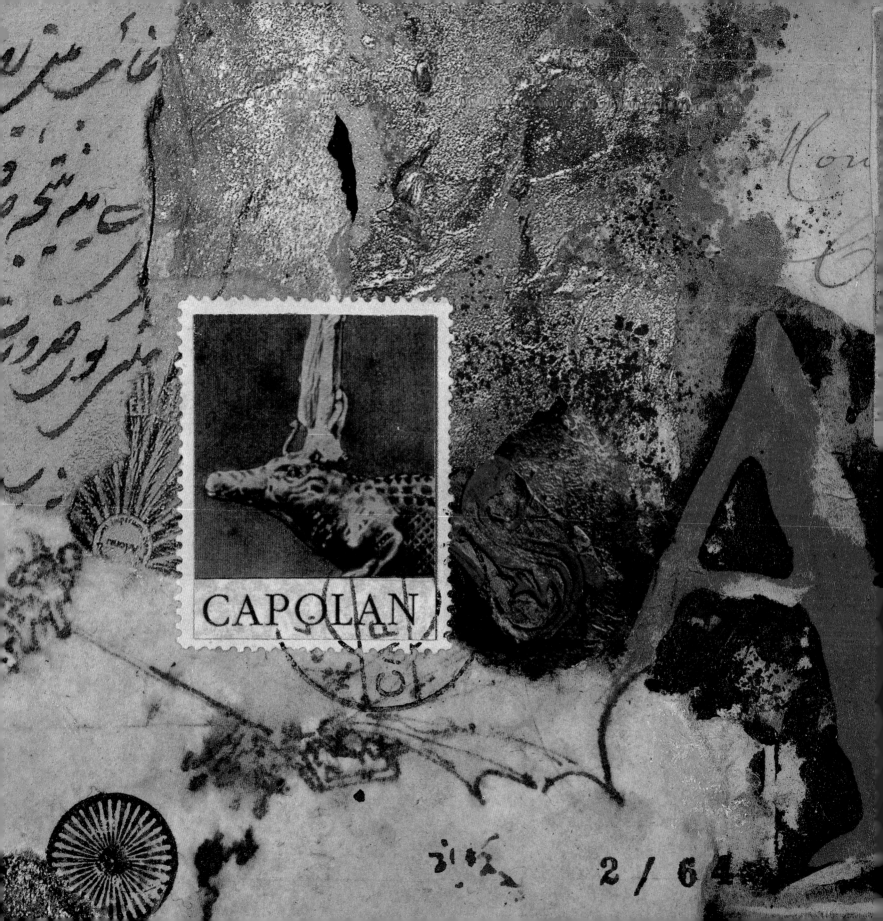

CAPOLAN

2 / 64

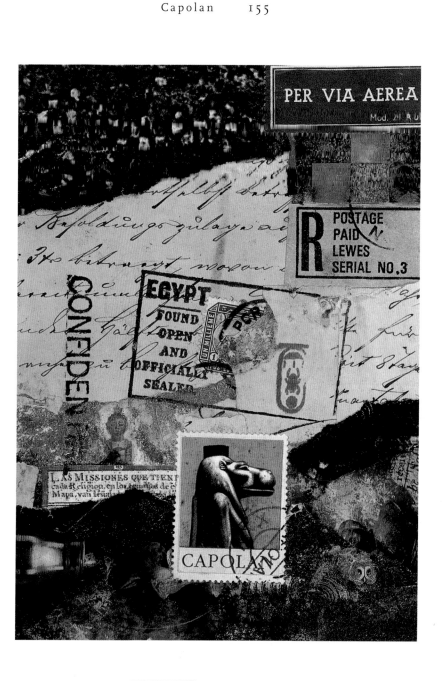

LEFT: Segment of the booklet cover from the *Capolan ArtBox.*

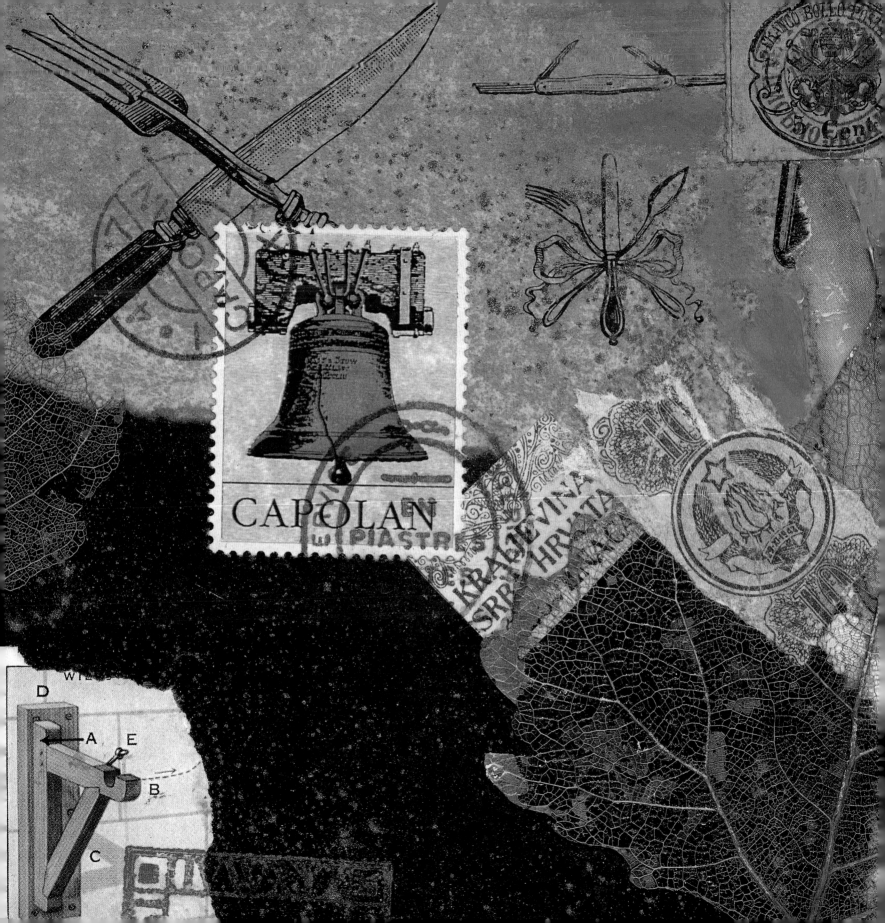

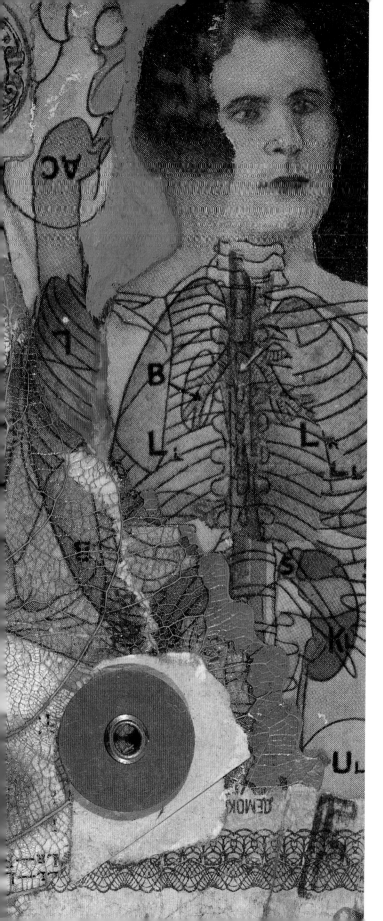

LEFT: Remains of a Capolan cutter's compass.

Ritual: The Egg Ceremony, which is held twice yearly, would appear to be a contest involving throwing eggs as high into the air as possible. But the true purpose of the event revolves around the quantity of ribald rhyming verse recited while the egg is airborne.

Marriage: The Capolanians have developed a natural balance between being an enclosed society and one that accepts new blood. When a person, male or female, wishes to marry an outsider, their prospective partner is asked whether they wish to join Capolan. If the answer is "No," then blessings and gifts are given, and the couple leaves to marry and live elsewhere.

If, on the other hand, the newcomer wishes to embrace the Capolan way of life, then he or she is accepted wholeheartedly into the arms of the community.

Wedding ceremonies within Capolan are highly individualistic. One notorious wedding in the 1920s brought together a thousand guests, and included a 50-mile bareback horse race, the building of a 15-foot-wide bed, and a singing marathon that lasted forty-two days.

Zoology: Animals have often played a big part in Capolan history. A case in point was the extraordinary event in Montenegro in 1675, when it rained frogs. The Montenegrins were so terrified that they desperately sought some dark explanation: When two Capolan children were discovered dissecting one of the dead amphibians, the blame was laid at their door, and the whole Capolan community was accused of witchcraft. In exchange for the two children's return, the Capolanians agreed to move elsewhere.

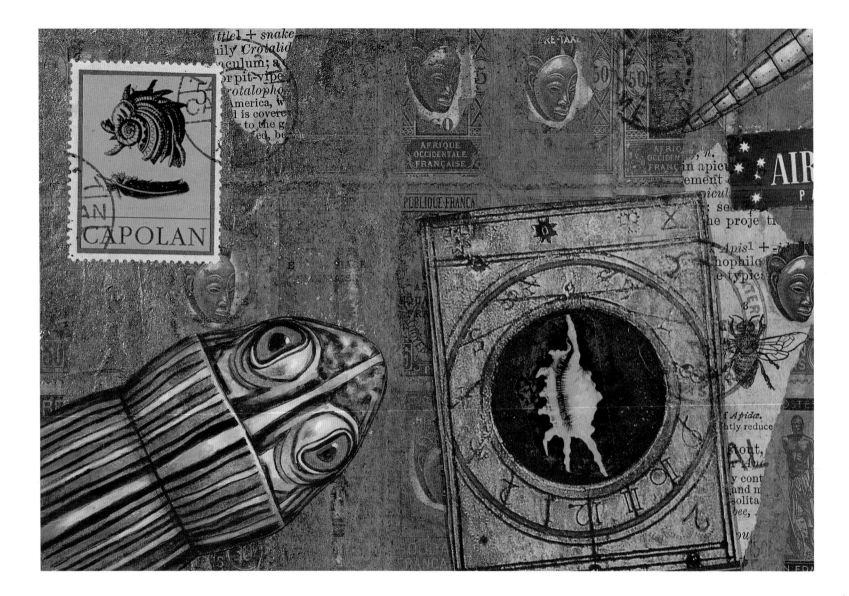

Travel: There have been at least three occasions when Capolan could have had a homeland of its own, but the people always voted against it. The council and citizens of Capolan have consistently believed that most political strife evolves out of territorial argument and an insecure leadership that exploits that conflict. By seeking a different kind of solidarity, the Capolanians have attempted to maintain their dignity, not through land ownership, but through a passing stewardship and compassion for one another.

Afterlife: Death, according to Capolanians, is a period of change. Death is merely the other side of being present. In their view, a rotting corpse is incontrovertibly dead, but so is a person refusing to wake up to his life.

The stilling of a loved one is either a prelude to rejoicing or a time of grieving, depending on the quality of life that was lived and not on the selfish preoccupations of those who remain alive. Some deaths may even require both a wailing and a wake.

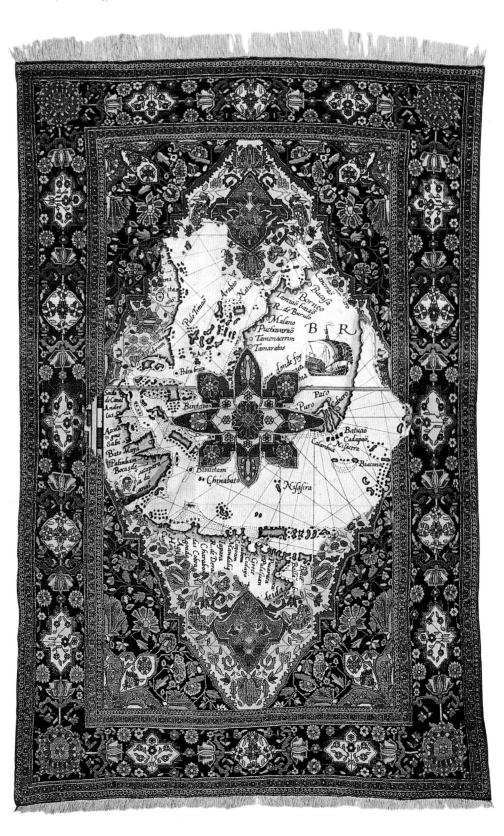

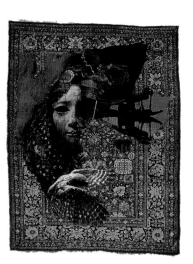

Two rugs from *The Museum at Purgatory*.
Magic carpets are seen into, not traveled
upon. These particular carpets were sent to
Edward Fitzgerald, the translator of *The
Rubaiyat of Omar Khayyan*, by the young
Persian woman who besotted him.

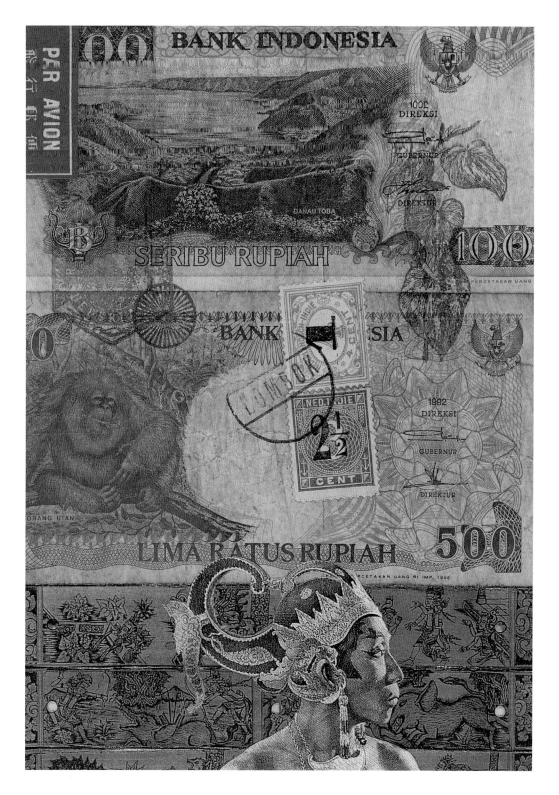

Two of six collages made while in Lombok, Indonesia. I find banknotes and maps irresistible.

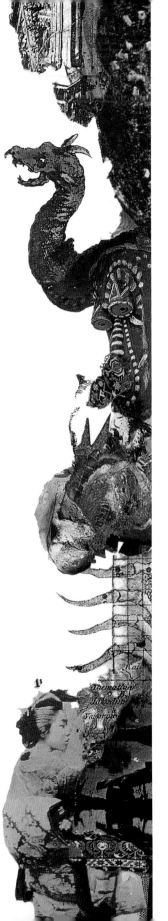

Four sections from a nine-foot-high, two-inch-wide strip panel for the curator's tale that appears at the end of *The Museum at Purgatory*. I wanted an ongoing image that would give the atmospheric sensation of Purgatory without illustrating it literally.

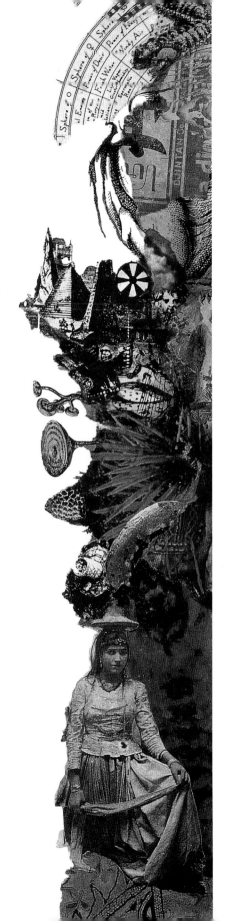

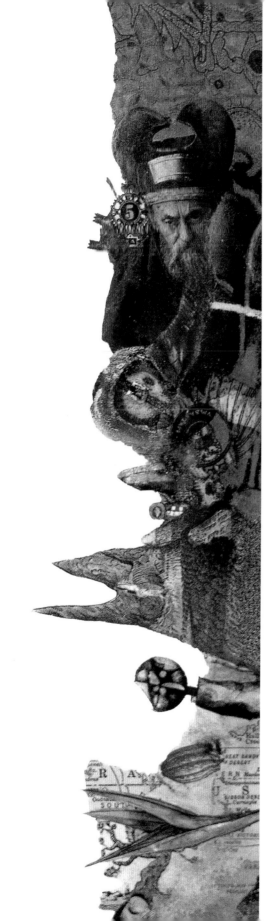
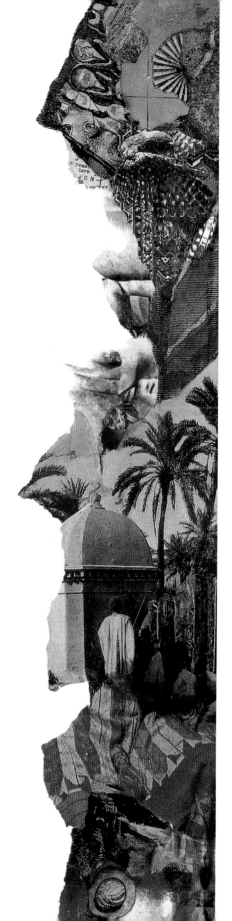

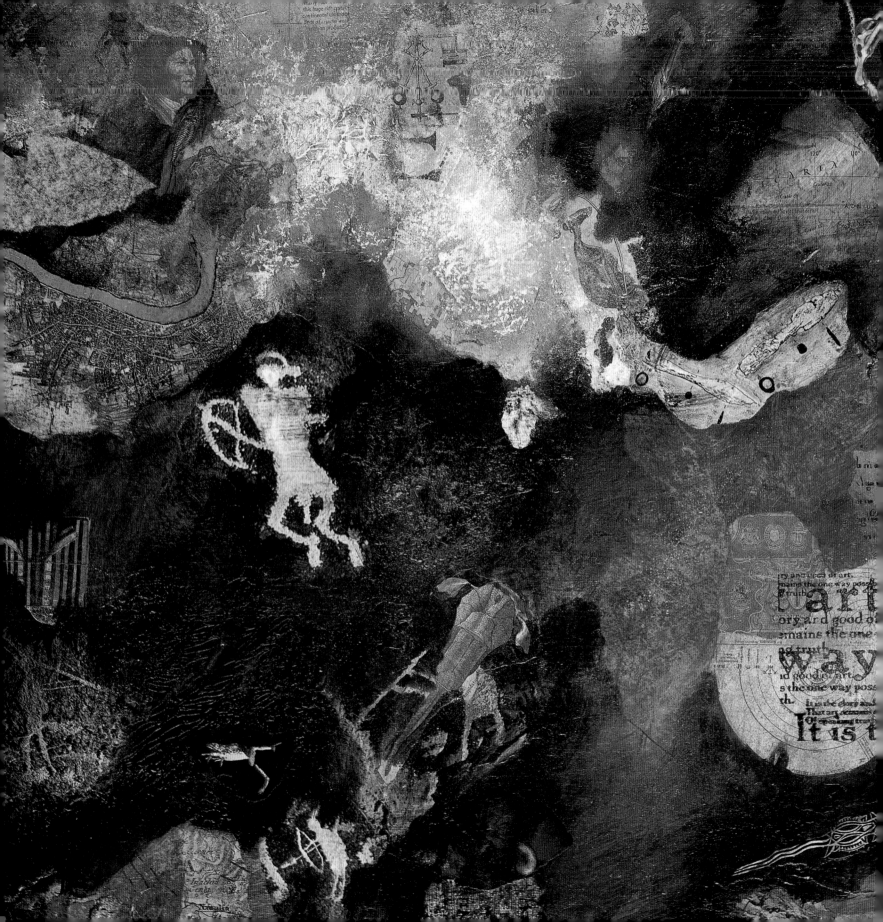

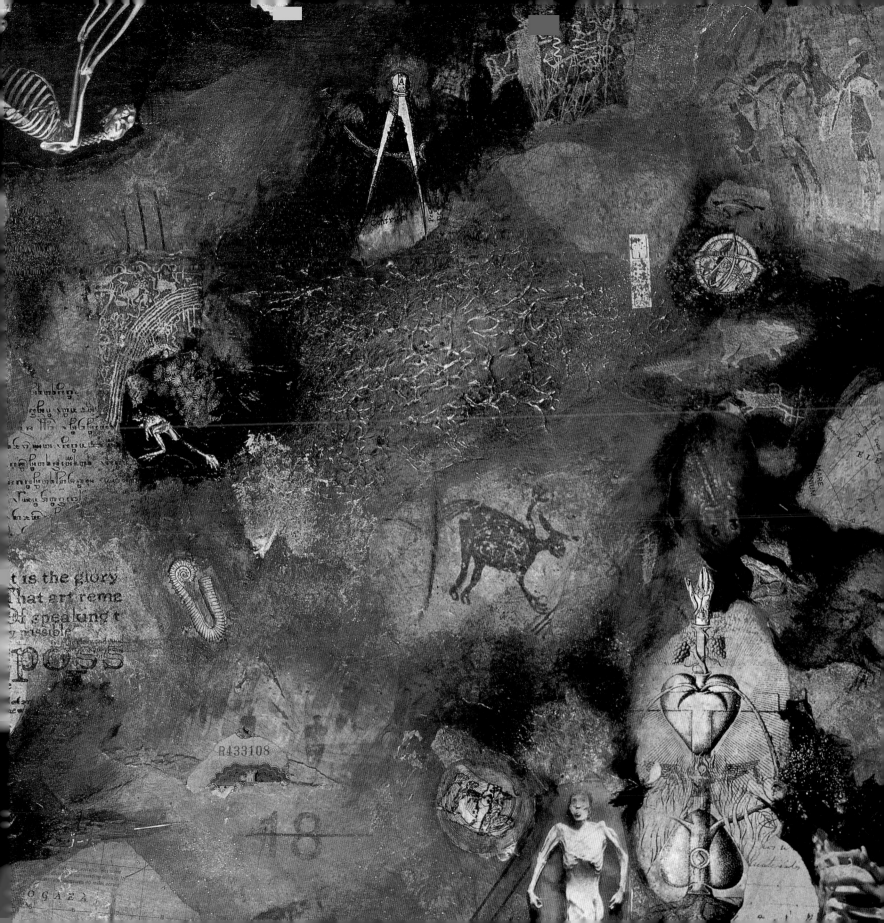

t is the glory
That art reme
Of speaking t
ssible

poss

PREVIOUS SPREAD: *The Hermetic Cave*
(1999)
RIGHT: *The Dysfunctional Family* (Not that
there is such a thing as a functional family!)
(1999)
FACING PAGE: *The King and Queen* (1999)

The Forgetting Room

BORRADOR

Rafael, the grandfather of the main character in *The Forgetting Room*, lives in the extraordinary, ancient Andalusian town of Ronda. I'd heard about the place from friends, but their enthusiasm in no way prepared me for its magnificence. The great gorge with its three-arched bridge (the arc of moons), the baked amber and white houses, and the cobbled streets have a way of enveloping visitors, leaving them strangers to their own century.

I'd been there a couple of days and was wandering the backstreets of Ciudad, the old town, when I found a courtyard antique store. Under a pile of old *Life* magazines I discovered a *borrador*. A *borrador* is a blank notebook, and the one I chanced upon was nicely bound, handwritten, and around a hundred years old. Between its pages were stuffed little scraps of paper that I knew would be perfect as collage material. I bought the book without bargaining.

Back at the hotel, I got into a conversation with a Swiss woman whose name turned out to be Marianne. Which was odd, because before I came to Ronda I'd decided to make Rafael's wife (Armon's grandmother) a Swiss woman called Mariane. During our conversation I mentioned the *borrador* and asked her how good her Spanish was, thinking that she might help me translate some of the inscriptions. She said she could try, but her ex-boyfriend, who was the hotel's owner, could probably do a far better job. She called him over and introduced him. His name was Rafael.

I began to realize I was on another of those coincidence streaks, and sure enough, when we showed Rafael the *borrador* he began laughing. Marianne asked him what was so funny, and he replied, "You see this mark? Here, on the first page. That's my grandfather's cancel. This was *his* accounts book."

But the name game didn't stop there. In my story, the full name of Armon's grandfather was Rafael Hurtago, and Armon's father shortened the name to Hurt. I picked the name Hurtago at random, and made use of the *hurt* part to try and show Armon's father's unconscious expression of pain. But it was only after writing the book's ending (where Armon changes his name back to Hurtago), that I spotted how appropriate the *ago* was.

ABOVE: Daydreaming in Andalusia, Armon imagines he sees Moorish script on the tundra, so he draws it on a scrap of paper from his pocket.
FACING PAGE: Cover for *The Forgetting Room*.